IMPROPERGANDA

THE ART OF THE PUBLICITY STUNT

Published by Vision On ©2000

This book is dedicated to the memory of my mother,
who willingly sacrificed so much in the cause of my
pursuit of a profession which she never quite got...

Mark Borkowski

CONTENTS...

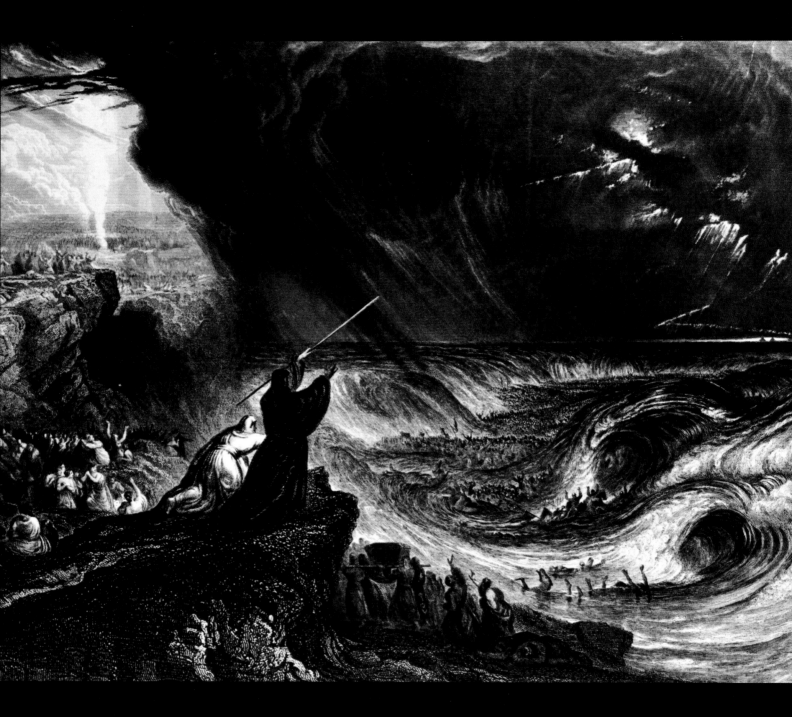

Moses comes to the Red Sea, pursued by the Egyptian hordes. They're getting closer and closer, and he's desperate - his people are trapped and will soon be slaughtered. "Look," he says, turning to his most trusted advisers. "I know what I'll do. I'll take my staff, I'll wave it high in the air, and I'll smite it against this rock. Then the sea will part, and a path will open up across it, with towering walls of water on either side. Then we shall cross - all of us - in perfect safety. And when the Egyptians pursue us across the sea, the walls of water will fold in on them, and they will perish in the tumult." His plan meets with a resounding silence. Then Moses' publicist steps forward and says, "Moses - you do that, and I'll get you three pages in the Bible."

THIS IS THE PRINCIPLE WHICH UNDERPINS THE APPROACH OF SUCH LEGENDARY PUBLICISTS AS PT BARNUM, JIM MORAN AND HARRY REICHENBACH, AND OTHERS CAST IN THE SAME MOULD, WHOSE ATTITUDES AND TECHNIQUES ARE CELEBRATED IN THIS BOOK.

eople with a formal training in PR or media and communications will have heard of Edward L Bernays. They'll have read his seminal work, *Crystallising Public Opinion*[1], in which he described the term 'impropaganda' as "the use of propaganda techniques not in accordance with good sense, good faith, or good morals ... methods not consistent with the American pattern of behaviour based on Judeo-Christian ethics".

Regardless of Bernays' coinage, for years publicists have used a technique we call "improperganda" - a term which encapsulates the approach to PR adopted by past masters of the art.

Improperganda is about claiming attention, capturing column inches and making news. It's about setting up situations which are so intriguing and so bizarre that they are irresistible to the press.

It's about creating images which tell those stories directly, or which lead readers straight to the copy to satisfy their curiosity. It's about entertainment.

This book pays homage to all the famous publicists whose stories taught us this. Most crucially, it's an illustration of the old adage that a picture is worth a thousand words. That said, you're looking at ten copies of *War and Peace*.

Special thanks are due to Candice Jacobson Fuhrman, whose comprehensive, entertaining and authoritative book *Publicity Stunt! Great Staged Events That Made The News* has been an invaluable reference throughout.

The amoral, senseless publicity Bernays described is actually propaganda, pure and simple. What follows is a resounding re-definition: a celebration of the true story of Improperganda.

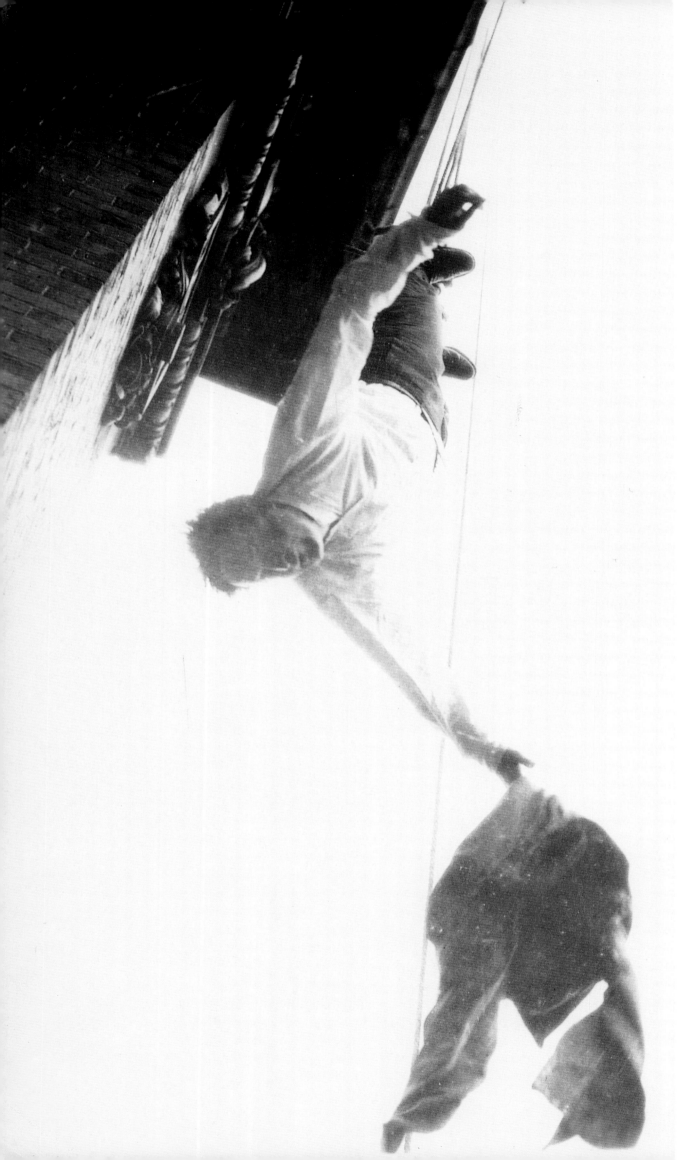

In front of around 50,000 people - the largest ever
crowd recorded at that time - Harry Houdini hangs
from the Munsey Building in Washington and effects
a dramatic escape from a strait-jacket.

1 | CIRCUS...

BACK IN 1987, A WILD-HAIRED FRENCH GYPSY CALLED
PIERROT BIDON TURNED UP AT MARK BORKOWSKI'S
OFFICE. HE PLANNED TO BRING A GRUNGY MAD MAX-
MEETS-BLACKPOOL-TOWER-STYLE CIRCUS TO
CLAPHAM COMMON IN A SMALL, SHABBY TENT. AS A
BUSINESS PROPOSITION, IT SEEMED UNSOUND.

Four years later, Archaos was on the road playing to crowds of five thousand at a time. Then the whole manic construction imploded under the weight of its own mythology, and the show left town for good. On the way, Archaos re-forged the ancient art of circus ballyhoo, which is at the root of all great PR.

In 1929, newsman Silas Bent observed that for the publicist, "If there is no excitement ready-made, some must be manufactured"[2]. In terms of manufacturing the excitement which draws press and punters, none were more accomplished than the legendary Phineus Taylor Barnum. He maintained that "the bigger the humbug, the better the people will like it"[3], and proved it time and again.

In the early days he exhibited a slave named Joice Heth, who recounted 'first-hand' tales of George Washington's youth, supposedly garnered from her experiences as the great man's nurse.

In 1835, this made her over 160 years old - a huge curiosity. To stir up controversy, Barnum wrote anonymous letters to local papers claiming that Heth was an automaton operated by a ventriloquist. His was a free-wheeling, fast-talking style based on an instinctive ability to improvise a tale or devise a spectacle which would entrap the credulous and cynical alike.

Barnum and his successors have been an inspiration to publicists the world over. If there were copyright on PT's ideas, his descendants would be rich indeed. These pictures pay homage to this heritage — here are freaks, daredevils and strong men who turned streets, parks and public places into spectacular platforms for performance.

Harry Houdini, famous for his public stunts, claimed, "I get more advertising space without paying for it than anyone in the country,"[4] a claim which encapsulates the very essence of great PR.

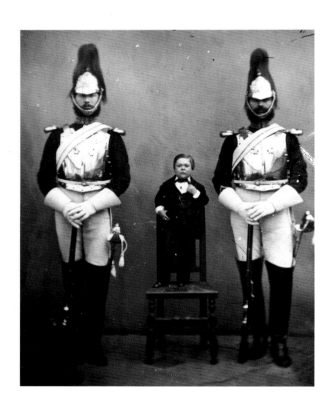

TOM THUMB
1860 © HULTON GETTY PICTURE COLLECTION

Tom Thumb, PT Barnum's tiniest exhibit and biggest asset,
stands 101 centimetres tall between two Horseguards.

BEARDED LADY
1907 © HULTON GETTY PICTURE COLLECTION

Suspicious stuff always translates into another willing,
paying punter. Is the companion of the camp-looking
guy in the trilby a man in a dress, or a bearded lady?

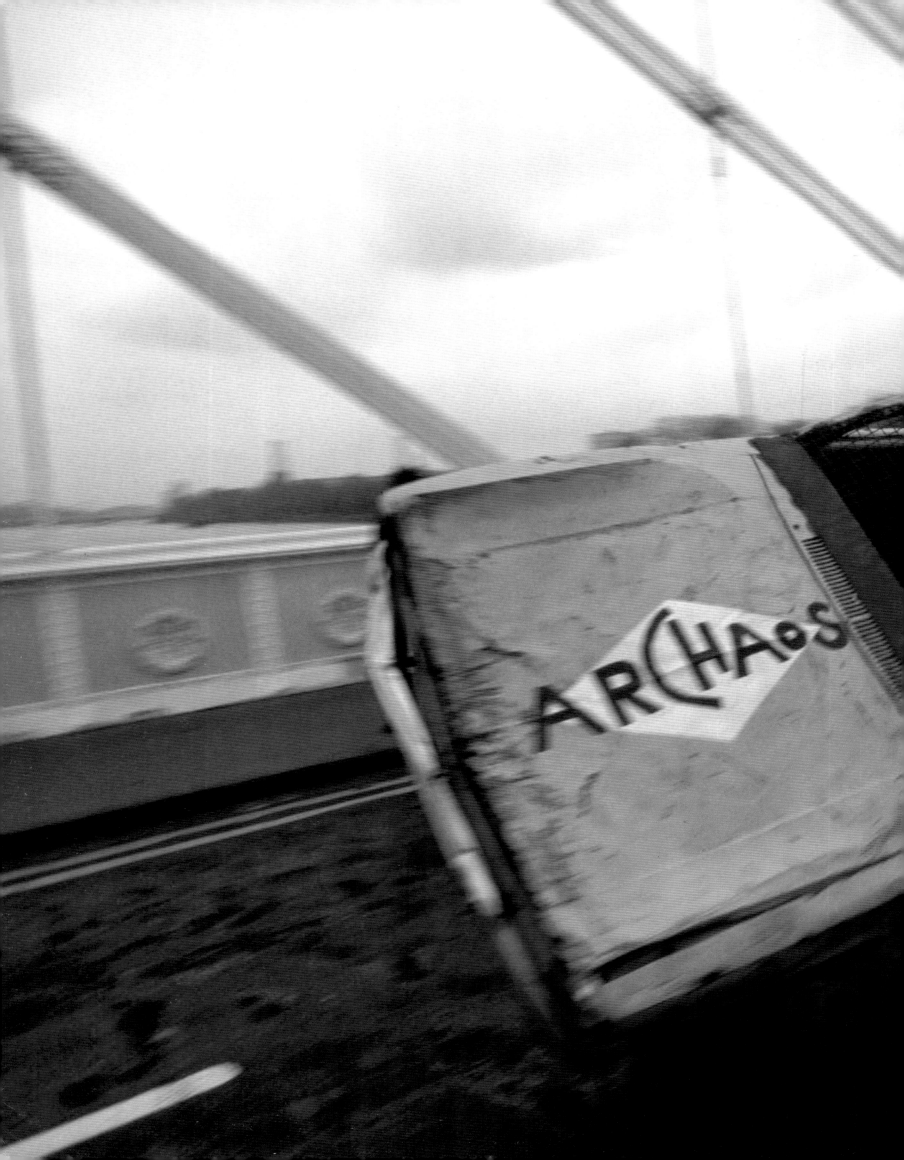

ARCHAOS - FULL TILT
1991 JIM HODSON © FRANK SPOONER
PICTURES/ BORKOWSKI PR

With barely any encouragement, Archaos split cars
in two along Edinburgh's Royal Mile, chainsawed
lamp-posts, jumped bikes over traffic queues and
demolished a building. Wrecked autos, donated by a
fascinated participating public, replace elephants in
a contemporary re-invention of carnival bally. If you
can't run away with the circus – give them an Escort.
A meticulous, commando-style operation results in a
two-wheeled crossing of London's Albert Bridge at
rush hour, and an arrest for dangerous driving
without a valid tax disc.

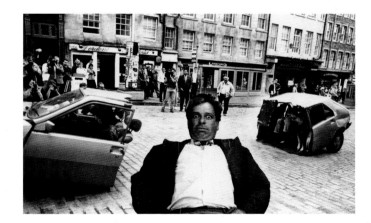

ARCHAOS - THE BIG SPLIT
1990 GERAINT LEWIS / BORKOWSKI PR

If the broadsheets won't go for the stunt, there's
always the possibility of a more intellectual
publication showing interest in the deeper
implications. Here, after Archaos splits a moving car
in two in Edinburgh's Royal Mile, Mark Borkowski
finds himself in an uncompromising position in a
front-page article on stunts in *The Independent*'s
Edinburgh Festival Guide.

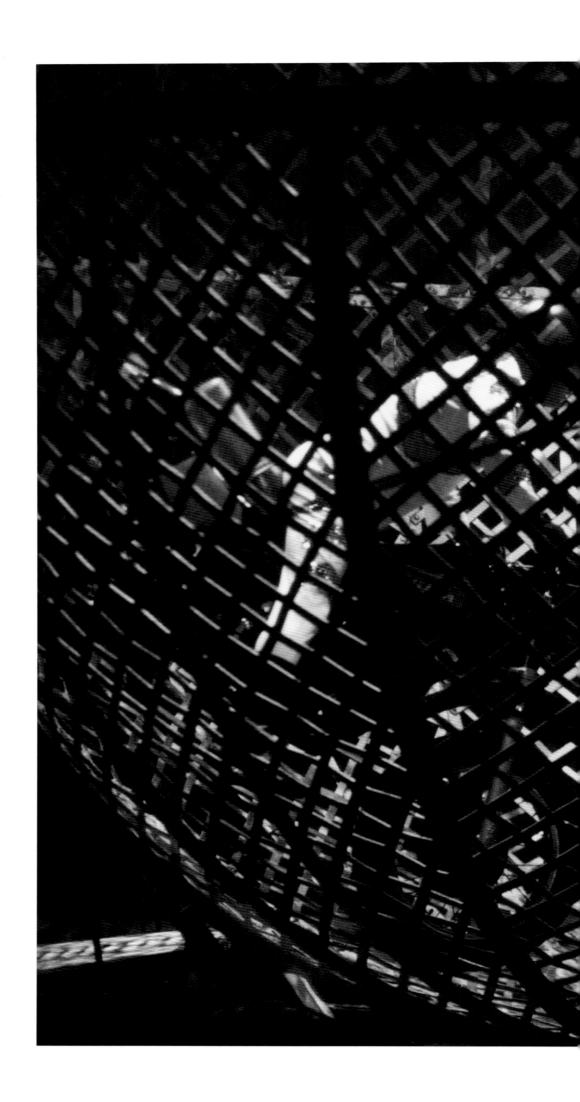

LOS TORNADOS

1992 IAN PATRICK / BORKOWSKI PR

Circus act Los Tornados takes a leisurely 60 mph trip round the Globe of Death. When the globe later fell off its stand and landed in an orchestra pit, it luckily failed to live up to its deadly title and became known backstage as the Globe of Minor Abrasions.

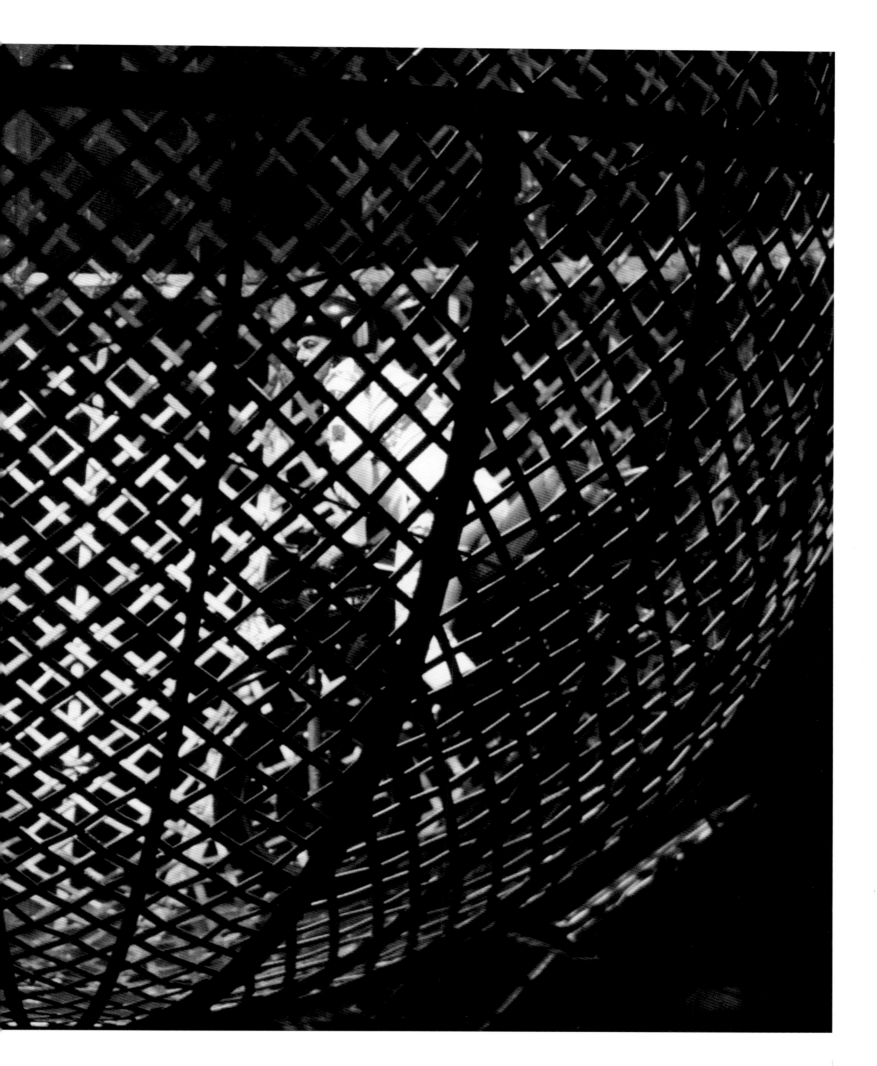

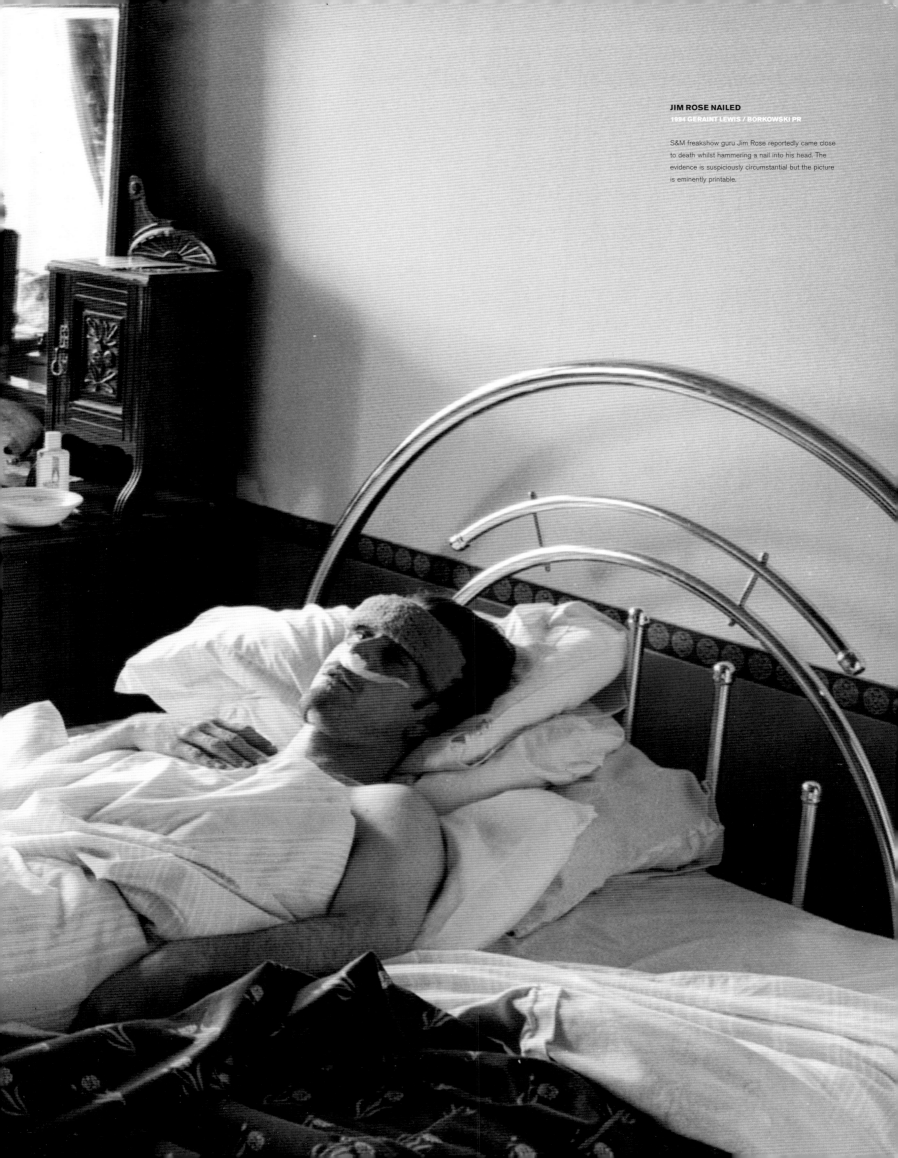

JIM ROSE NAILED
1994 GERAINT LEWIS / BORKOWSKI PR

S&M freakshow guru Jim Rose reportedly came close to death whilst hammering a nail into his head. The evidence is suspiciously circumstantial but the picture is eminently printable.

DE LA GUARDA

1997 WWW.GAVINEVANS.COM / BORKOWSKI PR

It's a PR nightmare when papers get a story the wrong way round, but with pictures it's not so important. This is De La Guarda. Anyone who's seen the show knows they're hanging from their feet. *Time Out* took the opposite point of view when they selected the image for their front cover.

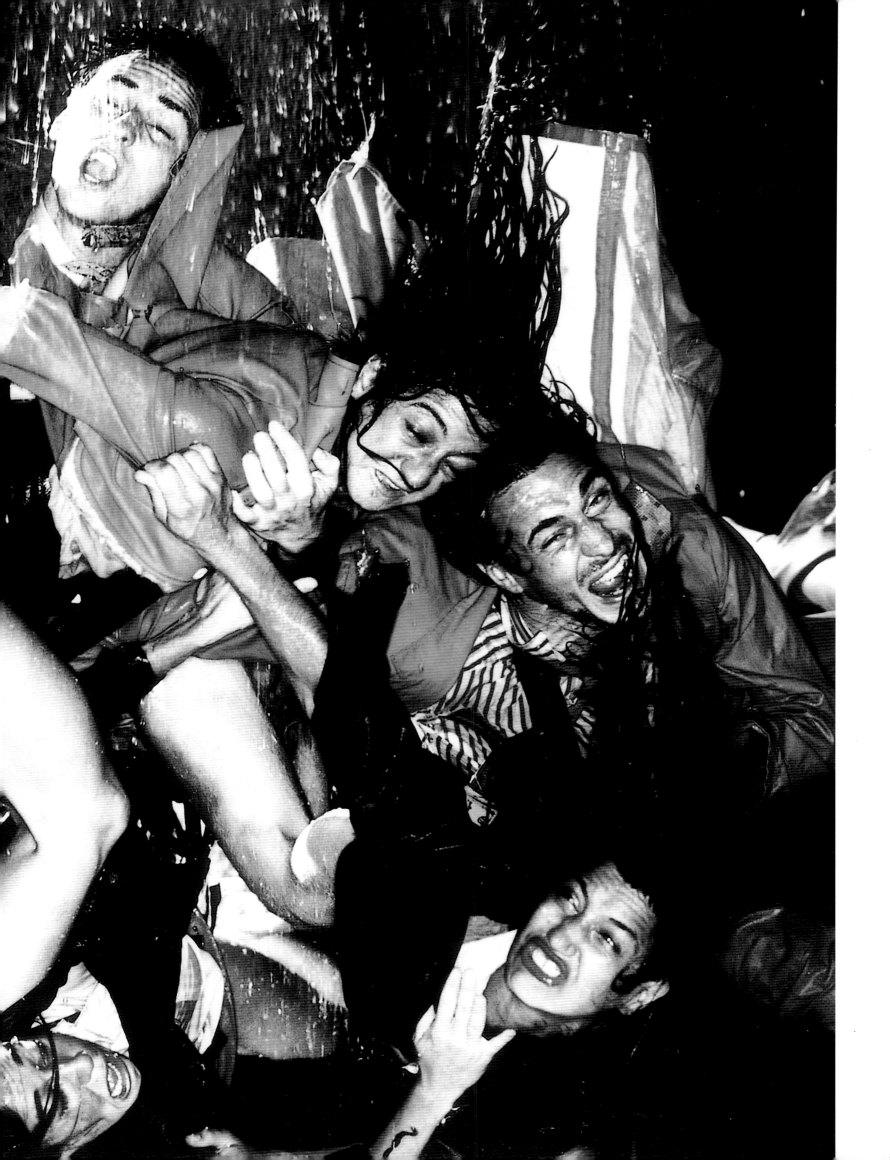

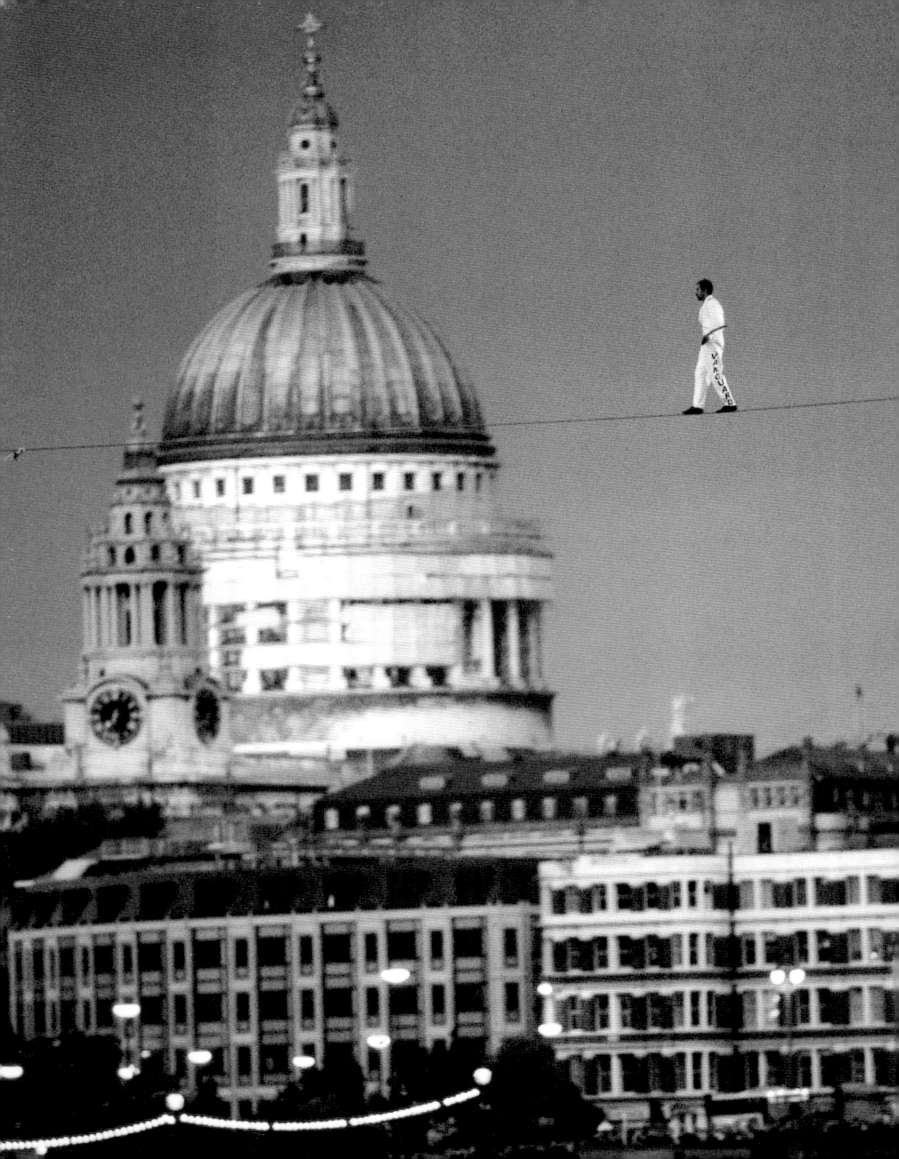

THAMES DOUBLE WIREWALK

1997 ANDRE CAMARA © N I SYNDICATION / BORKOWSKI PR

Some people will do anything to get to London's South Bank. Ex-Archaos star Didier Pasquette takes the easy route across the river. Unfortunately he meets Jade Kindar-Martin heading north, and the two have to climb over each other mid-stream, in the first ever double tightrope crossing of the Thames - a seven-feature stunt which was publicised worldwide.

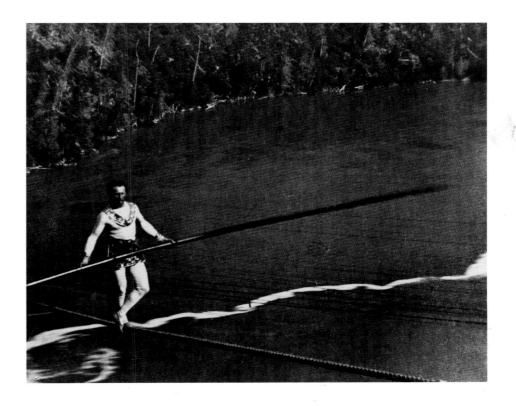

BLONDIN OVER NIAGARA

1859 WILLIAM ENGLAND © HULTON GETTY PICTURE COLLECTION

The original wirewalk spectacular was captured on camera nearly 150 years ago. Here Frenchman Jean Francois Gravelet (better known as Charles Blondin) nonchalantly crosses Niagara on a tightrope.

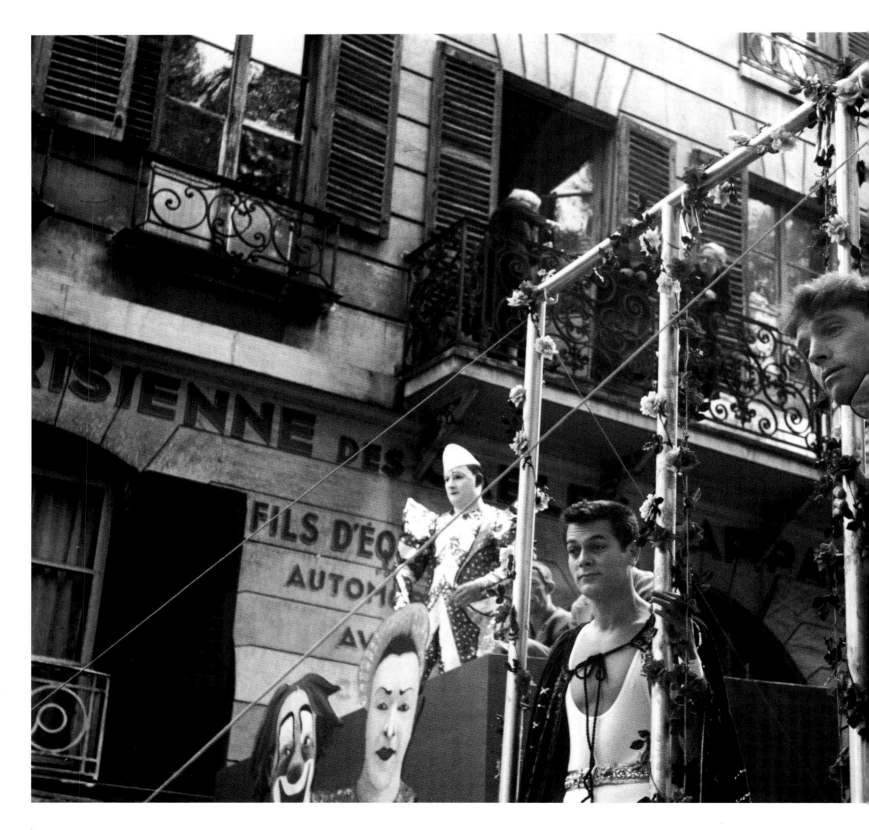

THE CURTIS AND LANCASTER CIRCUS PARADE

1955 JOHN CHILLINGWORTH © HULTON GETTY
PICTURE COLLECTION

Burt Lancaster and Tony Curtis take to the streets in a
circus parade through Paris to promote the film *Trapeze*.

HAIR POWER

1934 © HULTON GETTY PICTURE COLLECTION

In 1925, Ben Darwin pulls a seven-passenger touring
car along with his hair after an intensive training
programme with Pantene Pro V Conditioner.

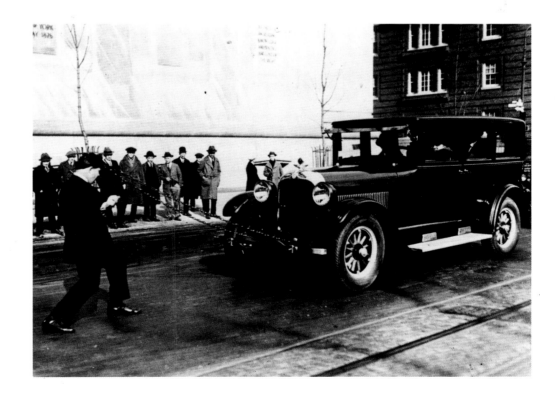

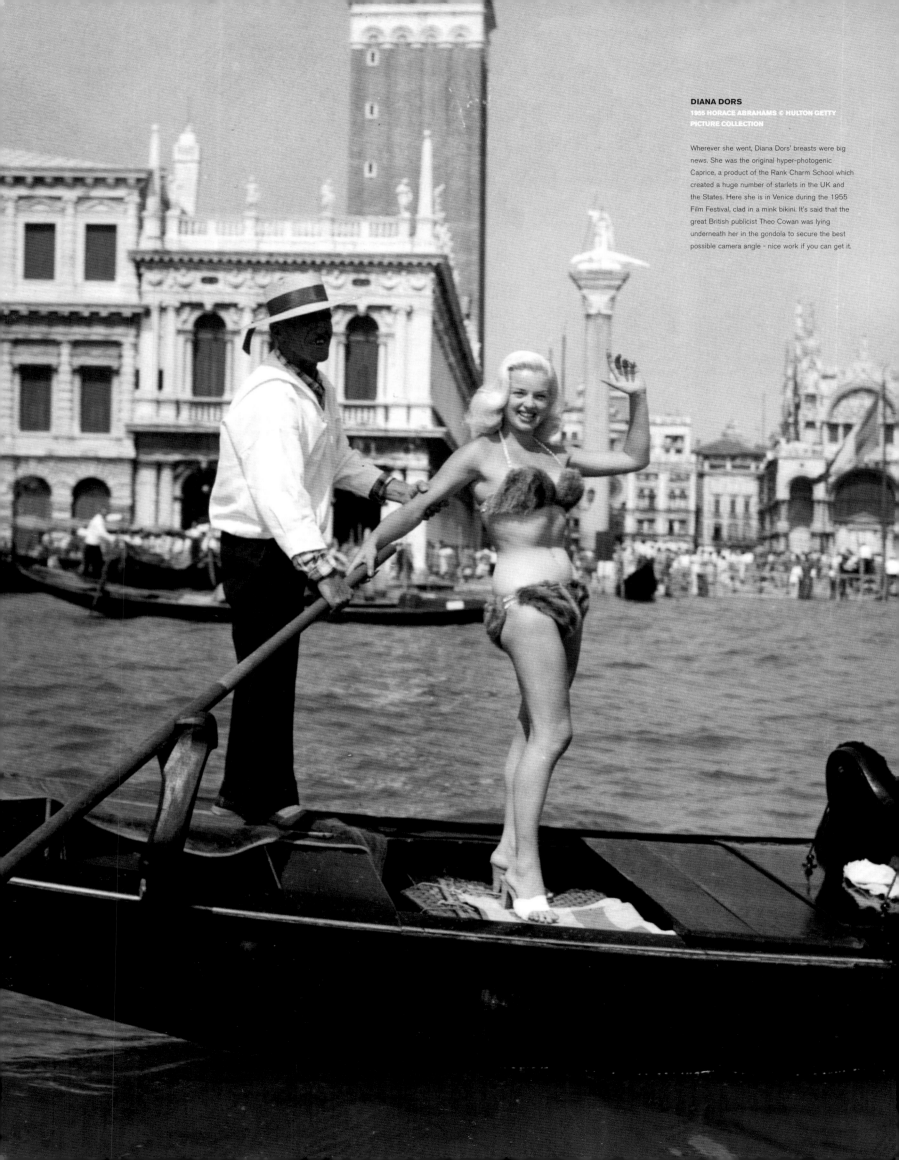

DIANA DORS

1955 HORACE ABRAHAMS © HULTON GETTY
PICTURE COLLECTION

Wherever she went, Diana Dors' breasts were big news. She was the original hyper-photogenic Caprice, a product of the Rank Charm School which created a huge number of starlets in the UK and the States. Here she is in Venice during the 1955 Film Festival, clad in a mink bikini. It's said that the great British publicist Theo Cowan was lying underneath her in the gondola to secure the best possible camera angle - nice work if you can get it.

2 | SEX...

DOWN AT THE DEEPEST, DARKEST AREA OF THE BRAIN IS A WALNUT-SIZED GLAND SPEWING OUT CHEMICALS WHICH TRIGGER PLEASURABLE SENSATIONS. IT'S ARGUED THAT SOME NEWSPAPER PICTURE EDITORS HAVE A COCONUT-SIZED CHEMICAL FACTORY WHERE THE REST OF THE POPULACE HAS WALNUTS. THEY CERTAINLY REPRESENT A MORE EVOLVED SPECIES, BUT ONLY IN THAT THEIR CHOSEN WORKING ENVIRONMENT PROVIDES THE PLEASURE CENTRE WITH A REGULAR SUPPLY OF STIMULANTS. OTHERWISE, THEY'RE ALMOST NORMAL.

Put another way, we are all sex-obsessed. Newspapers cater to our obsession, sex sells newspapers, and sex sells, full stop. There's no other reason to buy *The Sun*.

A pound of flesh is widely regarded as a fair price to pay to promote a product, and since time immemorial, publicists have used all their guile to find creative ways to effect the transaction, though given the nature of the market, they might well be wasting their efforts — the presence of a naked woman somehow makes the dullest of products very compelling indeed.

Perhaps now is the time to raise, and ignore, the thorny issue of principle. Are publicists evil perpetrators of sexist imagery and attitudes? Are they cheerfully complicit in the process? Are they faintly embarrassed by the whole business? Or do they just turn a blind eye and sod the consequences? For the majority, it's probably just an incidental part of the job, and specious reasoning suffices to paper over any unsightly issues underneath.

In a profile of Russell Birdwell in 1944, the *New Yorker* commented, "A press agent who worries about taste is as badly miscast as a soldier who faints at the sight of blood."[5] And as the critic Jim Dilinger once said, "Just because you work for the Inland Revenue doesn't mean you like paying taxes."[6] So think what you like of the following, but don't pretend you don't enjoy it.

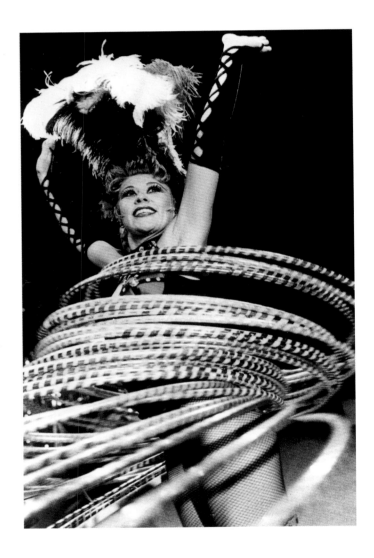

JOAQUÍN CORTÉS

1996 FRANCESCO ESCALAR / BORKOWSKI PR

Flamenco dancing is sexy stuff. But guys with moustaches in tight black suits don't look too hot in the contemporary media environment. Joaquín Cortés is sexed up and subjected to the hideous indignity of becoming a steaming hunk of the month.

ELENA THE HOOLA HOOP QUEEN

1995 STEPHEN SWEET / BORKOWSKI PR

This great tale provides the perfect excuse for publishing a picture of an old woman in fishnet tights. Elena, the Hoola Hoop Queen from the Moscow State Circus, was said to be so spectacularly sexy that the show's drummer suffered a heart attack and fell off the stage, sustaining a broken wrist to add to his coronary. (His successor insured himself against collateral damage, smartly securing the follow-up story.)

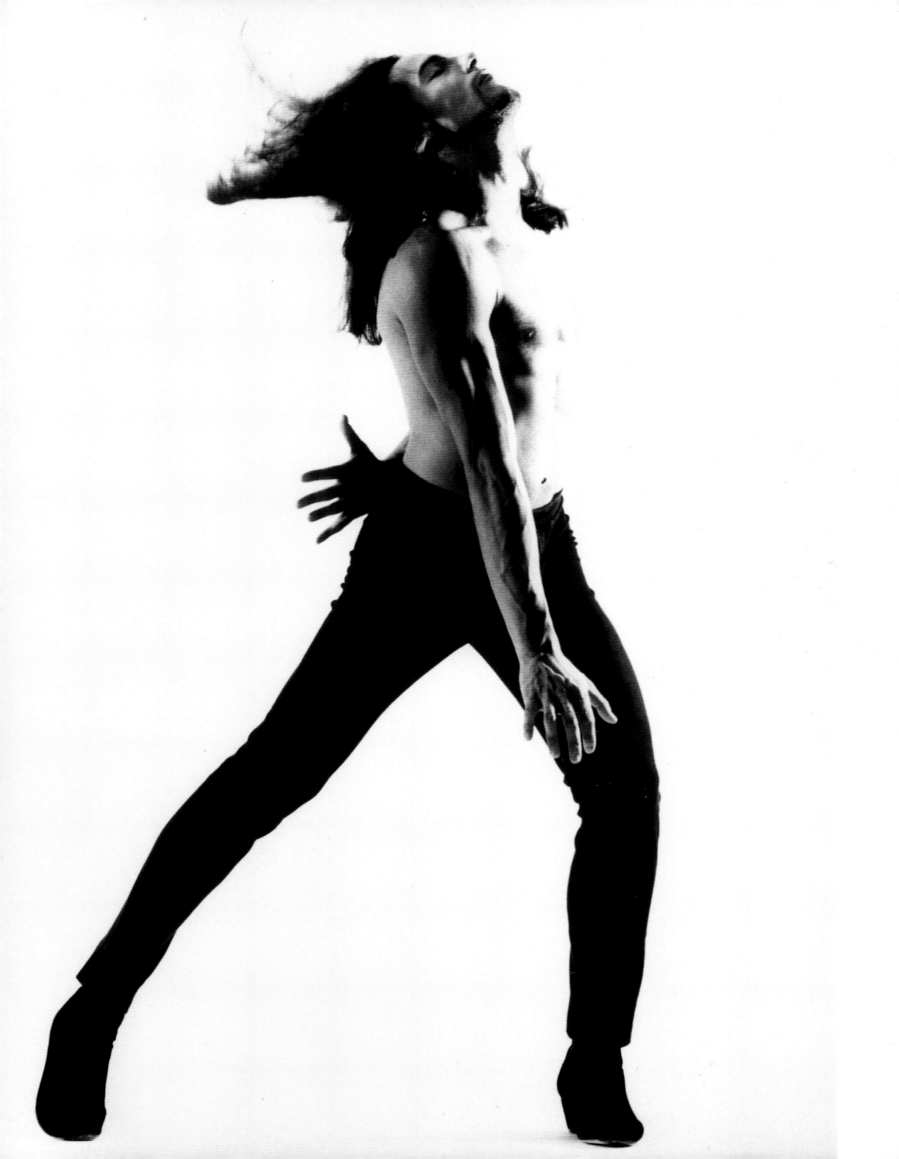

THE UNCUT JOEY MANTONI

1991 PETE MIATT / BORKOWSKI PR

When Borkowski PR managed the Cabbage Patch Kids account for Hasbro UK, the impending arrival of American performance artist Joey Mantoni (infamous for a show which involved the dolls in sado-masochistic practices) at the Edinburgh Festival seemed too good an opportunity to miss. With the tale ready to run in a broadsheet, Hasbro got cold feet, and the agency had to provide the papers with an unpublishable photo of Mantoni to kill the story. This is one of Mantoni's more modest offerings.

CLUB TROPICANA

1997 PAUL MASSEY © FRANK SPOONER PICTURES / BORKOWSKI PR

In the back streets of Cuba, the juxtaposition of squalor and extravagance publicises the presentation of Club Tropicana at the Royal Albert Hall, promoted by Harvey Goldsmith and Bill Curbishley.

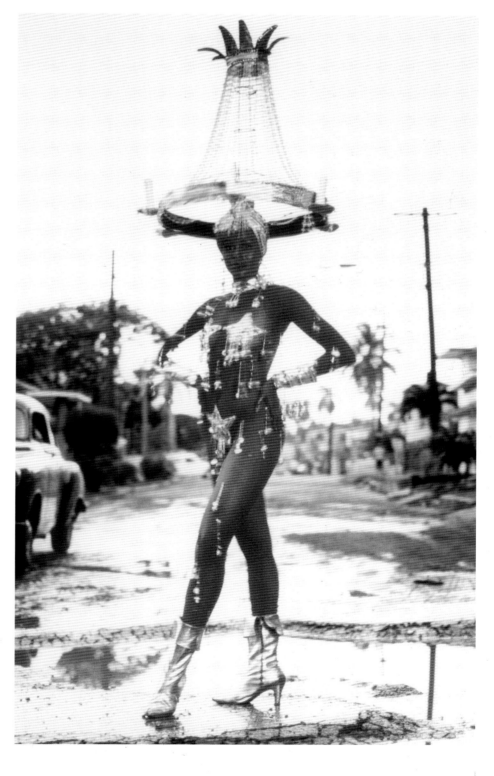

**ENGLISH NATIONAL BALLET GIRLS
EXPOSED**

1999 PAUL MASSEY c FRANK SPOONER
PICTURES / BORKOWSKI PR

"When you think of ballet, you think of wrinkled
prunes in evening suits squinting through plastic
binoculars at men in tights": this was the gospel
according to *Loaded*, until they were presented
with *Swan Lake* in terms they understood.
Classic brand re-positioning used sex to sell
ballet to an unexpected audience. As any hooker
will tell you, the same tricks work every time.

590

Fleurette
Jewelry

MARILYN MONROE
1955 © HULTON GETTY PICTURE COLLECTION

The amount of exposure a photo can get is amazing,
if it happens to combine a pavement grating,
a powerful wind machine, and a gorgeous film star.
Marilyn Monroe famously loses control of her
clothing to publicise *The Seven Year Itch*.

SINDY

1991 **WWW.GAVINEVANS.COM / BORKOWSKI PR**

In a tribute to the great Herb Rits, Sindy goes up-market into *Elle*, sells herself as a three-dimensional sex symbol, and reminds every 30-something reader of the childhood pleasures they can pass on to their own offspring.

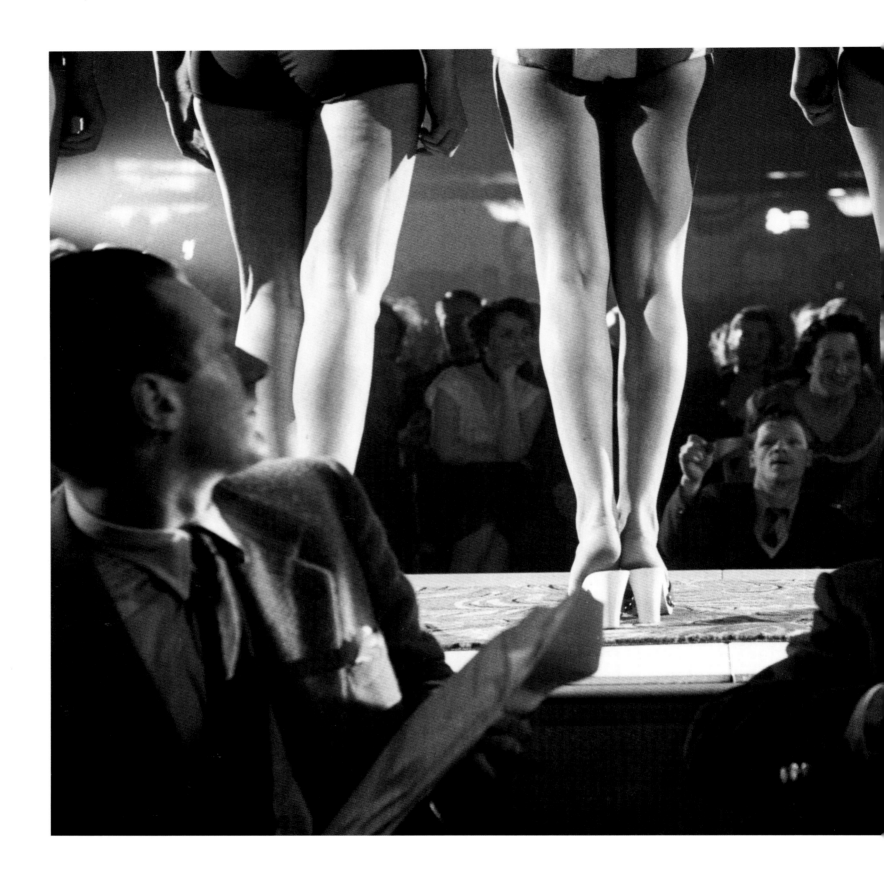

MISS WORLD

1953 THURSTON HOPKINS © HULTON GETTY
PICTURE COLLECTION

Presumably these Miss World contestants had upper
bodies, but the Picture Post decides to cut to the
chase. Eric Morley created the competition to give
Mecca a glamorous point of difference, at a time when
clubland was perceived as seedy and disreputable.

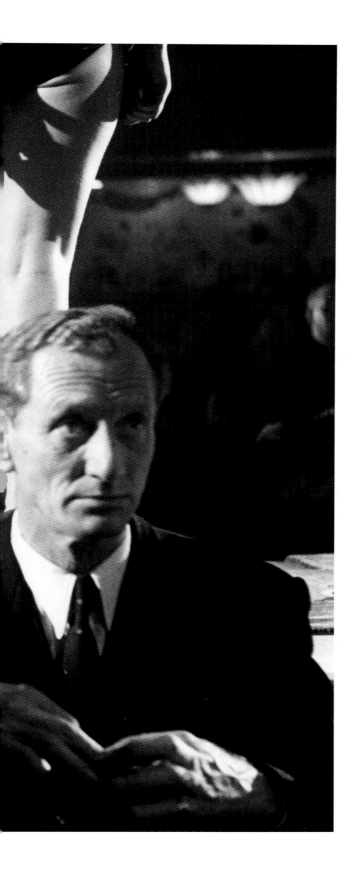

PLAYBOY BUNNY AUDITIONS

1966 © **HULTON GETTY PICTURE COLLECTION**

In this excellent summation of British gender politics,
a bunch of luscious lovelies pose decoratively on a
scaffolding overlook bunny Dolly Read, while a group
of wannabes are hard at work building profile
for Europe's first Playboy Club at the London Hilton.
Whatever line you take on his vision, Hugh Hefner
knew how to make it happen.

**CROOKES LABS IMMUNISATION
PROGRAMME**

1963 © **DAS FOTOARCHIV**

The top award for canny use of near-nudity has to go
to this shot from the 60s, promoting the desperately
dull news of an influenza vaccination programme carried
out by Crookes Laboratories. The lab elected to make
London's Windmill Theatre its first port of call, after
discarding such obvious options as schools, hospitals
and factories. And imagine the temptation that must
have plagued the headline writer: feel free to run up
your own variations on big hoses and little pricks.

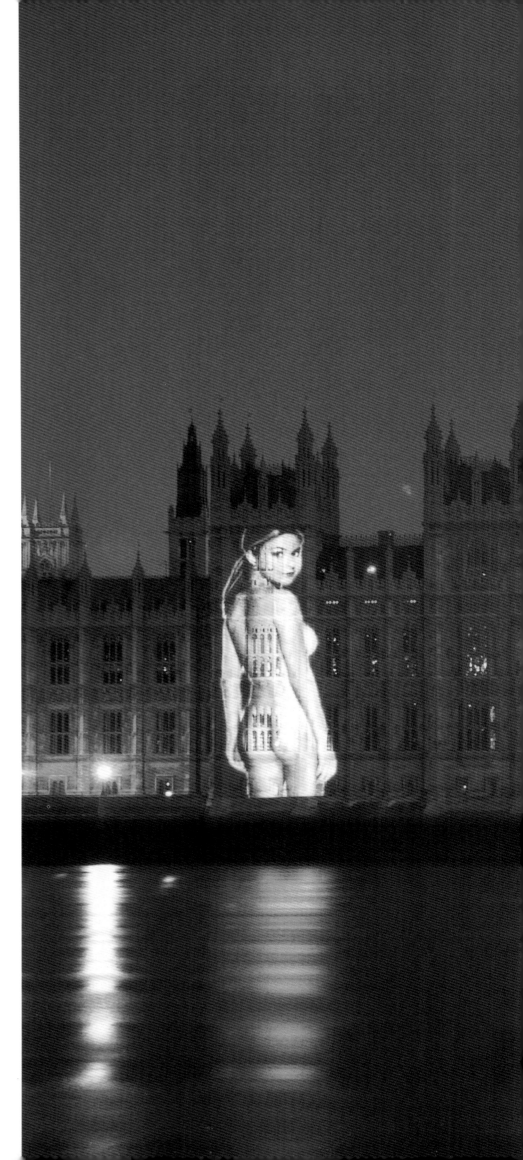

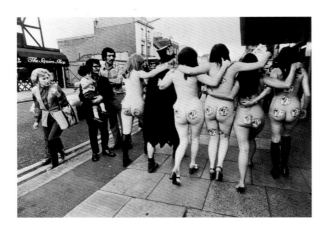

NAKED PROMOTION - LORD SUTCH

1972 © **HULTON GETTY PICTURE COLLECTION**

It looks like they've all got bad verucas on their arses, but despite the medical implications, the sight of Lord Sutch strolling down Oxford Street with five naked ladies to publicise a rock festival at Wembley Stadium is eagerly picked up by the media. So are the women, who were arrested and taken away in a Black Maria after leaping from a bus outside 10 Downing Street.

GAIL PORTER

1999 MICK HUTSON © FHM

Children's TV presenter Gail Porter projects her adult
credentials, marking her attempt to appeal to an
altogether less sophisticated target market.

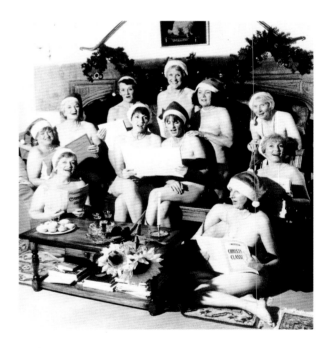

WOMEN'S INSTITUTE CALENDAR

1999 TERRY LOGAN © LEUKAEMIA RESEARCH FUND

The much-caricatured cake-baking, embroidery-
stitching Women's Institute exposes its underbelly of
steaming sexuality with this much-celebrated naked
calendar. Featuring several of its middleaged members,
it proves a huge moneyspinner for leukaemia research.

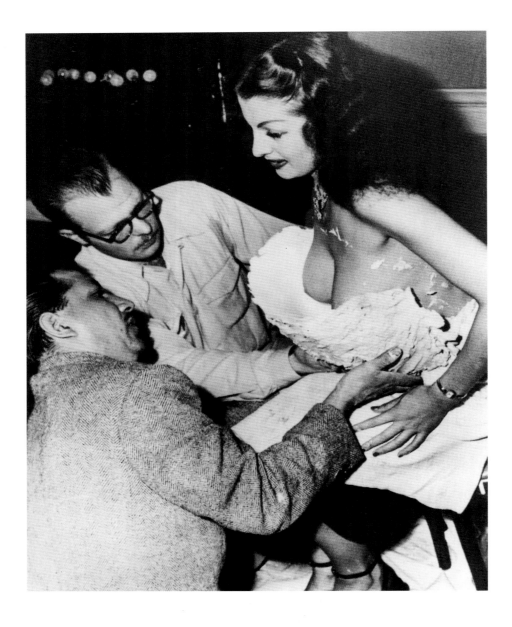

BREAST IMPRESSION
1934 © DAS FOTOARCHIV

As further proof that a career in insurance is more than it's cracked up to be, two representatives from a San Francisco firm find themselves grappling with the 42C cupped assets of local variety queen Tempest Storm. Ostensibly, they're creating a breast impression to back Tempest's bid to insure her bosom for $50,000.

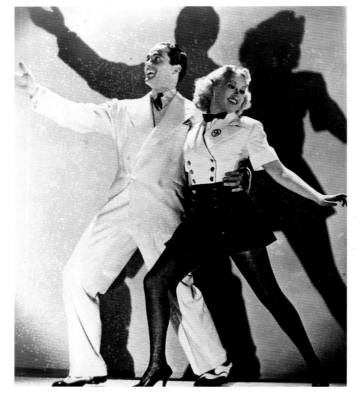

MILLION DOLLAR PINS
1937 © HULTON GETTY PICTURE COLLECTION

To any internet-savvy 12-year-old, this is about as arousing as your average *Carry On* film. But in 1937, that hint of thigh emerging from Betty Grable's slit skirt was the stuff that wet dreams were made of. The excuse for printing the photograph was that her legs had just been insured for one million dollars, which accounts for the startled expression of her partner, Charles "Buddy" Rogers. And wouldn't you just know it, the powers behind Betty managed to take out the policy just before she opened in the musical comedy *This Way Please*.

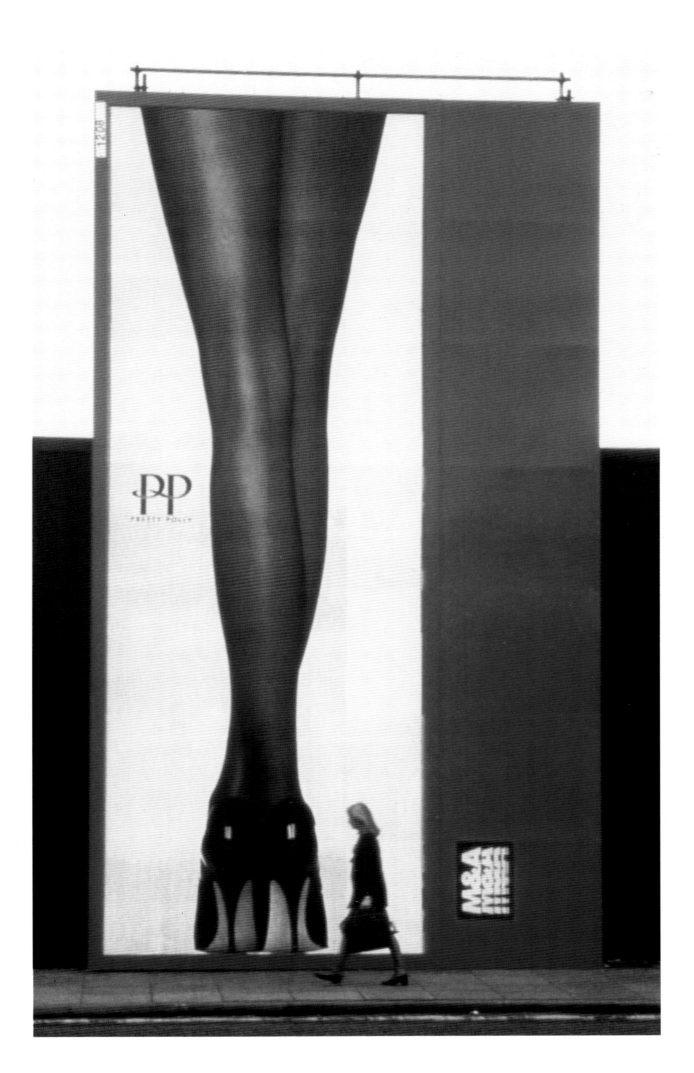

TREVOR BEATTIE'S LEGS
1996 TREVOR BEATTIE / TBWA / JACKIE COOPER PR

Trevor Beattie pulls the added-value-to-billboard stunt with a big dose of sex, a large portion of Pretty Polly and a huge load of media coverage (fuelled by crashing traffic).

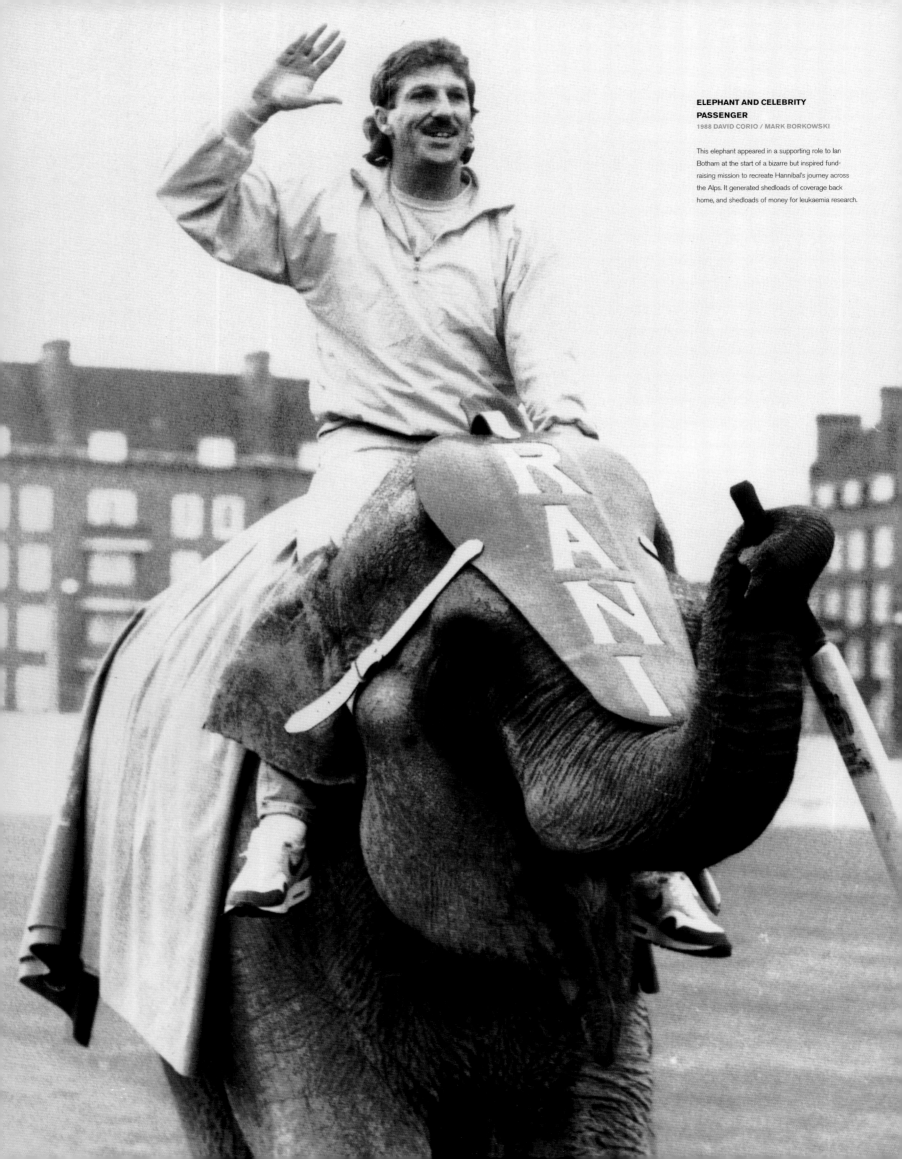

ELEPHANT AND CELEBRITY PASSENGER
1988 DAVID CORIO / MARK BORKOWSKI

This elephant appeared in a supporting role to Ian Botham at the start of a bizarre but inspired fund-raising mission to recreate Hannibal's journey across the Alps. It generated shedloads of coverage back home, and shedloads of money for leukaemia research.

3 | ANIMALS...

NO MATTER HOW CYNICAL WE ARE, AND NO MATTER HOW STRENUOUSLY WE PROFESS OUR CONTEMPT, THE IMAGE OF SOMETHING FLUFFY OR DOE-EYED CAUGHT DOING SOMETHING IT WOULDN'T, SOMEWHERE IT SHOULDN'T, ALWAYS CAPTURES OUR IMAGINATION.

When newscasters have run through the usual roster of death, disaster, and the collapse of Western society as we know it, they'll turn to camera with a wry and comforting smile which signals that all is well with the world, because there's a chicken on a BMX, a fag-smoking frog or a baboon surfing the internet. Perhaps it appeals to us because, after snoring through the 'real' news, animal stories trigger some synapse which wakes us up, ready for the really important stuff, like what John Kettley thinks is in store for us over the bank holiday weekend.

In the papers, bizarre images of animals leap out and grasp the bollocks of our attention. Every publicist on the planet knows the trick: offer a wild enough picture, and the story becomes irresistible.

The PR menagerie is enormous and the stories are legion. Paramount once trained fifty parrots to repeat "It ain't no sin" (the title of a forthcoming Mae West movie), to appear at cinemas when the film launched. But – tragedy of tragedies – the studio changed the title to *I'm No Angel* at the last minute (or at least, that's what the press release proclaimed). At a hugely well-attended press conference, producers admitted they'd had to release the parrots back into the jungle. This terrible disaster produced the expected outcome: everyone knew that a new Mae West movie called *I'm No Angel* was in the offing.

Jim Moran once decked a squad of homing pigeons in patented de-fogging sunglasses, to prove they flew faster than their unspectacled comrades. Unfortunately, no one bothered to find out which pigeon won - it was the manufacturer's PR victory which mattered. A Swiss bank publicised its move to new headquarters with camels - a stunt made all the more media-friendly when an employee fell off, broke his leg and was dragged down the street by a bolting dromedary. Horses have had makeovers, cows have visited barbers and nurses have stuck Band Aids on whales.

With animal stunts more than any other kind, we know we're being duped. So what - the delightful preposterousness is all that matters.

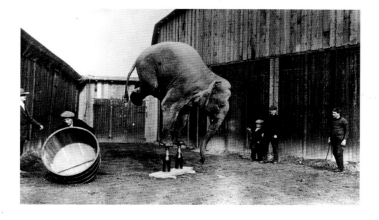

ELEPHANT TRAINING

1920 © HULTON GETTY PICTURE COLLECTION

Trawling through the annals of the industry, it's difficult not to conclude that the ever-popular elephant is actually having the last laugh. Their astute manipulation of human sensibilities keeps them in permanent employment.

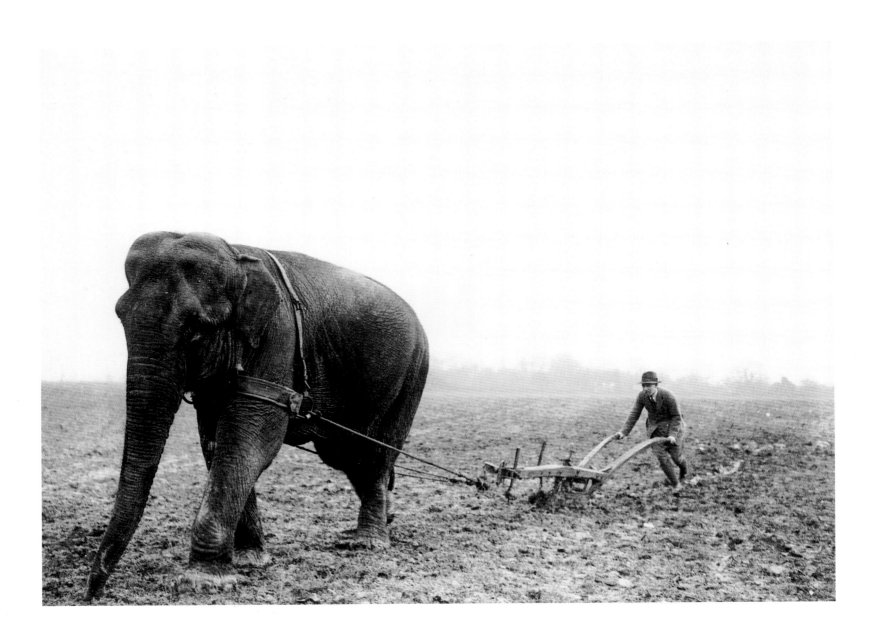

BARNUM'S TRICK

1926 © HULTON GETTY PICTURE COLLECTION

Taken at the headquarters of Sangar's Circus in
Horley, this photo proves there's nothing new under
the publicity sun. It's almost a direct theft of a stunt
pulled time and again by PT Barnum. As his train
drew into town, an elephant pulling a plough would
nonchalantly arrive alongside the tracks. Barnum is
long gone, but it's still illegal to plough fields in North
Carolina using elephants, because an outraged
farmer, fed up with his land being mulched in the path
of Barnum's omnivorous PR machine, pushed a bill
through the state legislature to ban the practice.

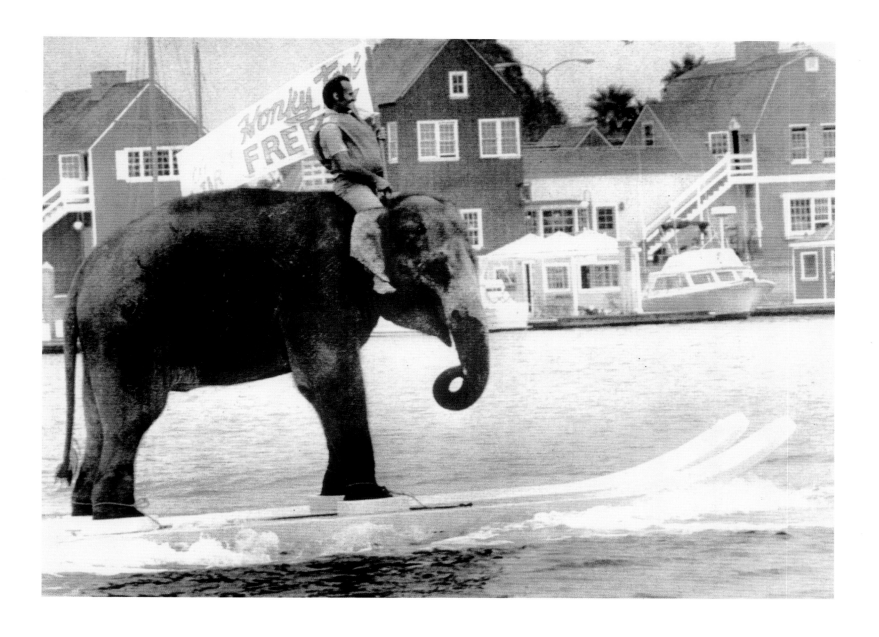

ELEPHANT ON SKIS

1981 © UPI / CORBIS

This elephant serves as a moving billboard to advertise the film *Honky Tonk Freeway*.

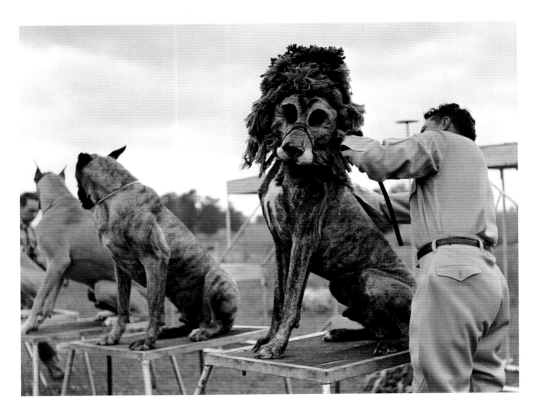

BIG DOGS AS BIG CATS

1956 DON c HULTON GETTY PICTURE COLLECTION

What do you do when you want to run a circus act with performing lions, but they scare you shitless? In the 50s, big wuss Robert Baudy made a big display of handling big cats, but used big dogs for safety's sake. By fixing masks on their faces, he transformed a bunch of docile boxers into rampaging lions, and then had the audacity to blow his own cover in a cheap bid for fame. But the audience identified with the lily-livered trainer and loved the act.

JOSIE THE TAP-DANCING DOG

1983 FRANK HAGGIS c NEWHAM RECORDER / MARK BORKOWSKI

After auditioning for Variety Night at the Theatre Royal Stratford East, Josie the cross poodle-terrier was set to appear tap-dancing to the theme tune from *The Streets of San Francisco*. Press interest bubbled away nicely, but just as photographers prepared to turn their lenses on this remarkable spectacle, Josie was killed by a pantechnicon whilst out for a walk along Windmill Lane. It was a tragic tale, which Mark Borkowski was tragically unable to keep out of the papers. The council, suddenly aware of the grave danger to pedestrians, banned heavy lorries from the lane.

HENRY UNFROCKED
1974 GRAHAM WOOD © HULTON GETTY PICTURE COLLECTION

The story goes that under all those folds of flesh, Henry (icon of the Chunky and Minced Morsels commercials) has as much of a penis as a Dutchman has a sense of humour. In short, Henry, like life, is a bitch, with the pups (and pictures all over the papers) to prove it. Is it the truth, or just a canny double-bluff?

VOTE HENRY

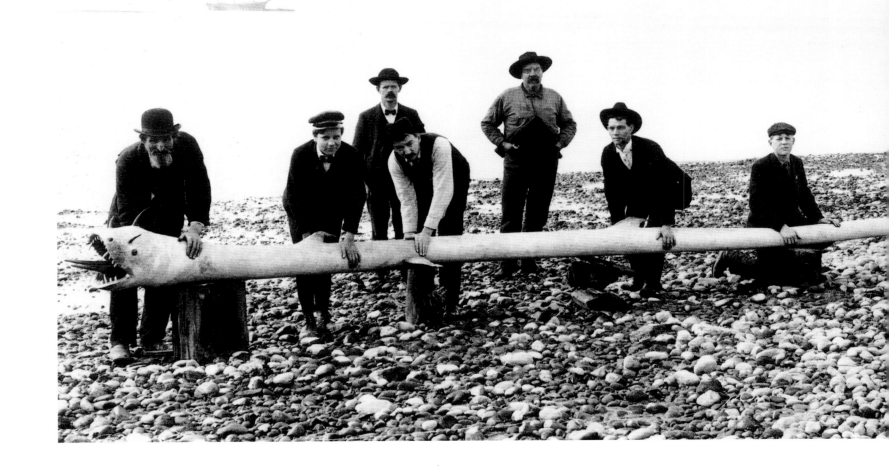

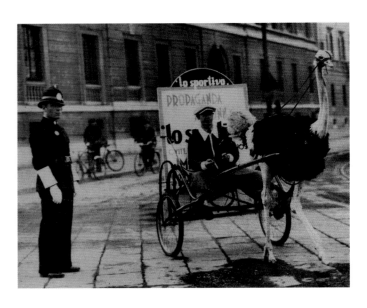

PETROL RATIONING IN ITALY

1939 © DAS FOTOARCHIV

In 1939, Benito Mussolini's expansionist plans led to action in Albania and a resultant fuel crisis. To encourage the populace to lock up their Lamborghinis and Lambrettas, the government's propaganda gurus enlisted the assistance of an ostrich. Having run out of ostriches, Italians now make do with Fiats.

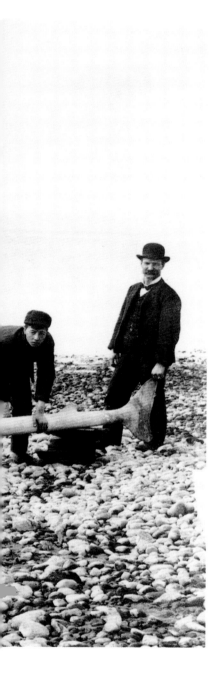

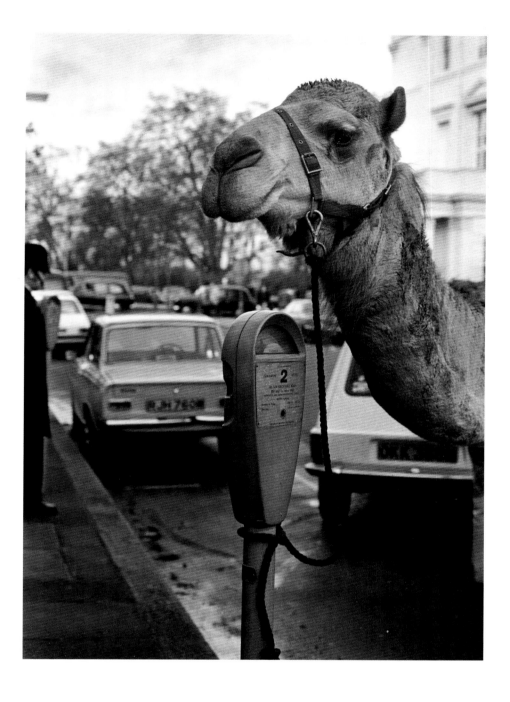

MONSTROUS HOAX

1906 © US LIBRARY OF CONGRESS

These guys look worried. They're concerned that the public may think that this bent, re-painted telegraph pole with bits stuck on is in fact a hideous sea monster. Suppose the misconception became popular: thousands of people who'd never heard of Ballard, Washington might be inspired to jump into charabancs and head to the resort. They could even end up staying in hotel rooms, eating candyfloss, going to amusement arcades and spending lots of money. It's an uncanny phenomenon -- similar problems arose when a man strapped two inner tubes to a plank and took a grainy photograph in Scotland.

STREET SCENE WITH CAMEL

1976 © HULTON GETTY PICTURE COLLECTION

Nonsensical but attention-grabbing, this camel was taking part in a stunt to publicise a Royal Gala Charity event at Olympia.

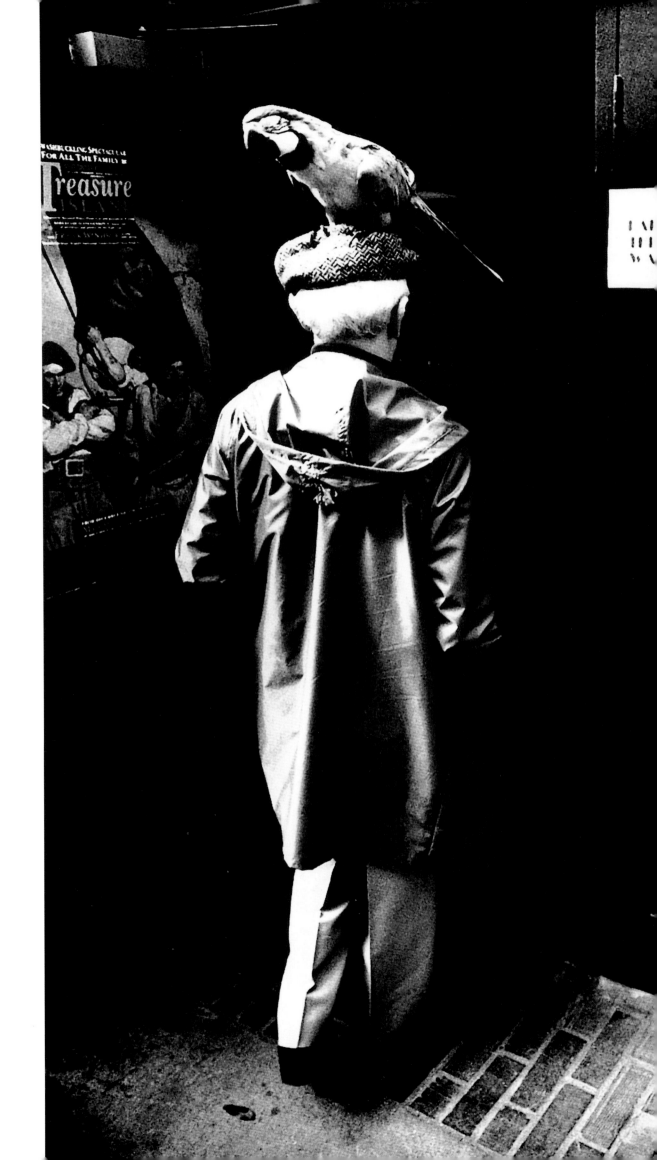

STAR-STRUCK PARROT

1989 PETER MCDIARMID © THE INDEPENDENT /
BORKOWSKI PR

Fighting a losing battle with Frank Bruno at the
height of his fame, the Mermaid Theatre's *Treasure
Island* badly needed ballyhoo to secure press
coverage. In a classic bit of cheek, they organised
auditions for Long John Silver's parrot Captain
Flint. The initial story raised a storm of coverage,
but that was only the beginning. Formula One
driver James Hunt's parrot Humphrey wins
the race for the audition... Humphrey is sacked
for picking up bad language from the stage crew
and taking a chunk out of the lead actor's ear...
A panic appeal is raised for a last-minute
replacement... And finally, as they say, a perfect
parrot flaps forward to take the part. Ironically,
before all this hiatus, hardly anybody had heard
of the Mermaid Theatre.

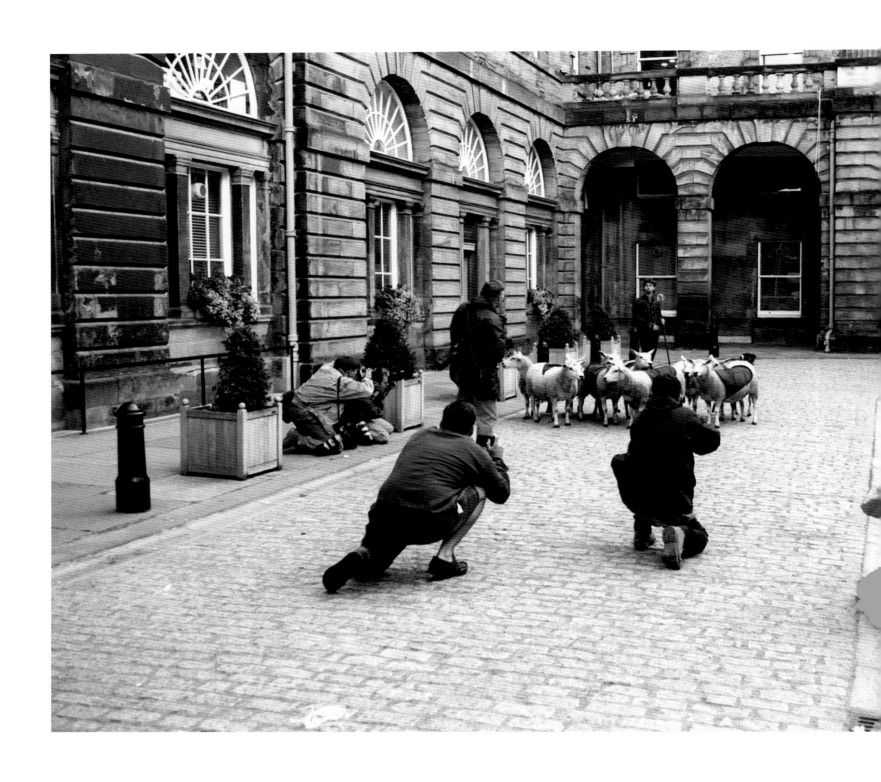

FELINE FEEEDING FRENZY
1974 REG LANCASTER © HULTON GETTY PICTURE COLLECTION

The myth endures about a certain cat food manufacturer which supposedly laced its product with additive substances to secure a loyal customer base. Subsequently, we were told that eight out of ten cats preferred the brand, before the advertisers realised it was the owners who bought the stuff and revised their strategy accordingly.

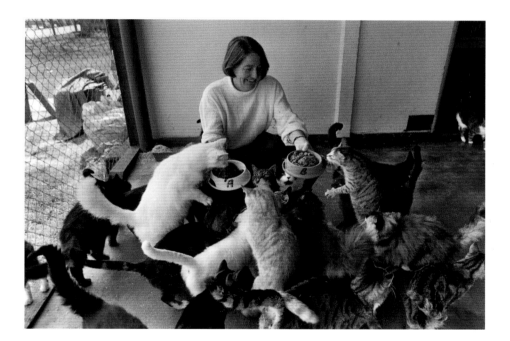

SHEPHERD JIM ROSE
1996 GERAINT LEWIS / BORKOWSKI PR

Jim Rose has earned infamy as master of the truly startling "Circus Sideshow" (imagine flatirons hanging from body piercings, beer evacuated from stomachs and drunk on stage, knives down gullets, light bulbs chewed - everyday stuff). This stunt exploits an arcane Edinburgh statute which allows any free-born sado-masochist to herd sheep through the centre of the city.

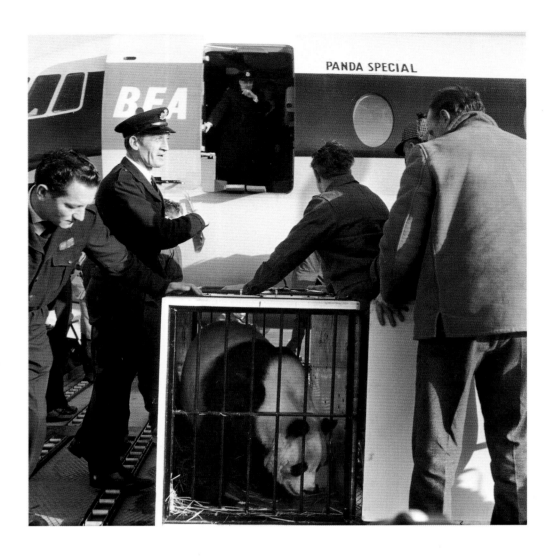

CHI CHI GOES FOR RUSSIAN SEX

1961 H THOMPSON © HULTON GETTY PICTURE COLLECTION

Animal publicity can be a shamelessly exploitative business. Though sexual inadequacy is a deeply private concern, in the case of Chi Chi, it becomes a cause célébré which provides London Zoo with a tremendous promotional platform: lack of sex sells. (One school of thought suggests that Chi Chi in fact possessed a rampant sex drive, which was suppressed for publicity purposes by BEA.)

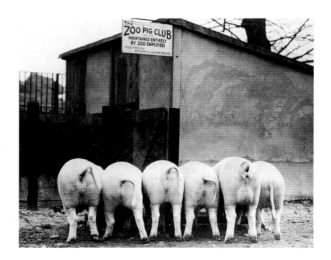

PIG CLUB

1941 © HULTON GETTY PICTURE COLLECTION

Promotion of the war effort, 1941. The London Zoo starts The Zoo Pig Club with six animals, fed on scraps collected from local catering establishments.

STAR AND STARLET

1952 © UPI / CORBIS

What's the difference between Anita Ekberg and Bonzo the Chimpanzee? One's a hugely successful movie star, and the other is the unknown Anita Ekberg. A bathing beauty contest, staged in 1952, focuses attention on the up-and-coming Swedish starlet. It's said that a publicist later met the two at a ball and asked Bonzo whether she would like to dance. When the chimp said yes, he reputedly replied, "Well, piss off over there and do it then. I want to talk to your mate." The same beauty-and-the-beast principle still holds good the world over.

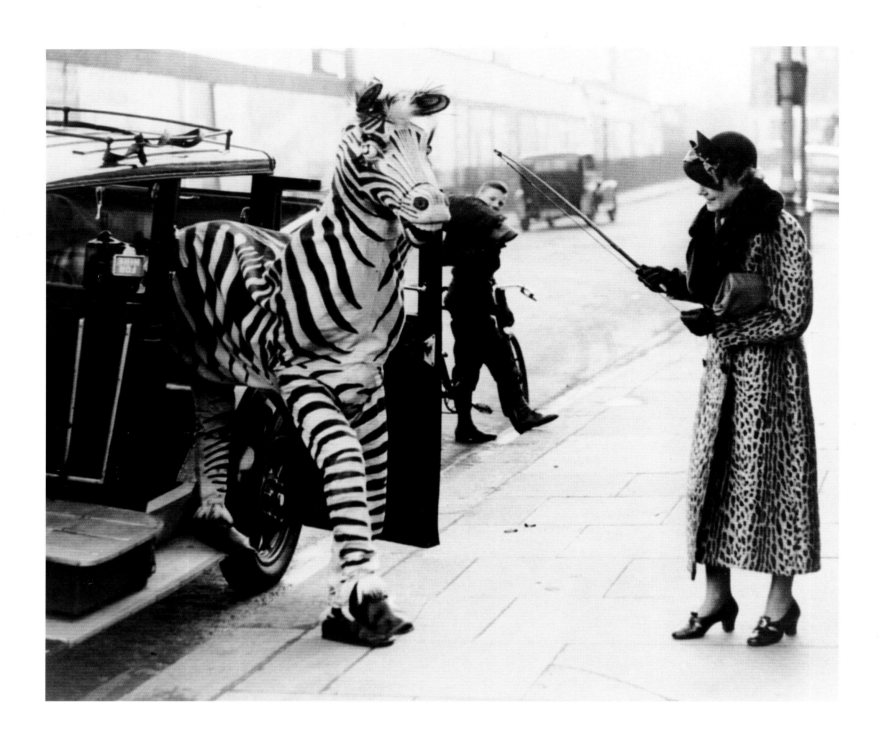

STRIPED PASSENGER

1937 REG SPELLER © HULTON GETTY PICTURE COLLECTION

Old people don't always talk arrant nonsense. When a 90-year-old cabby tells you that he had a stripy horse in the back of his cab once, his picnic may still be fully packed. Plotless and purely bizarre, this picture demands a double take and pulls the reader right to the heart of the matter: the premiere of a London circus show in the 1930s.

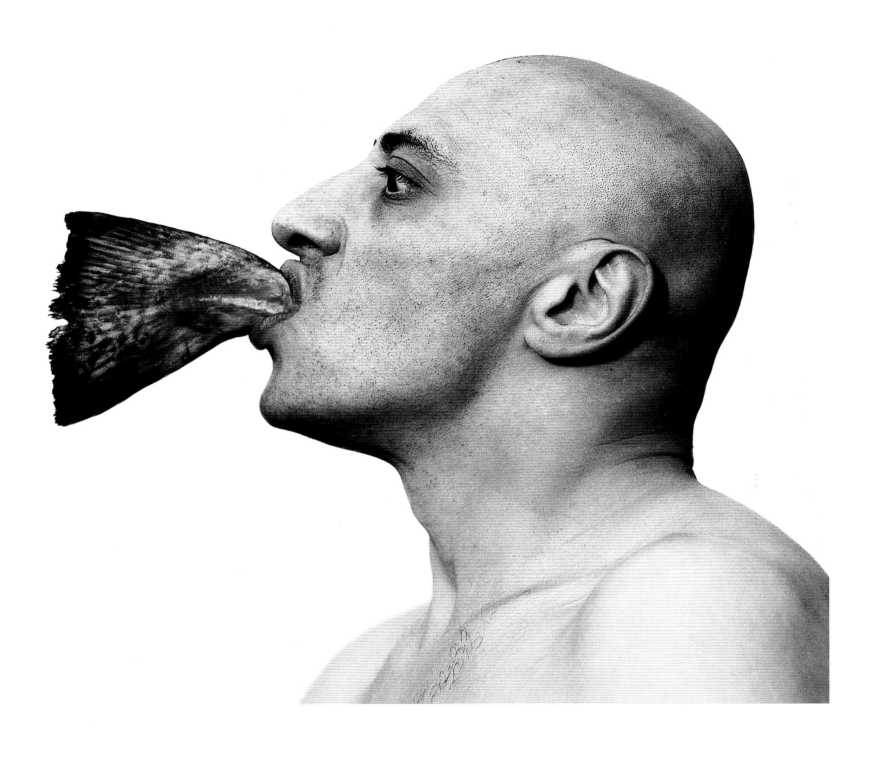

THE ARCHAOS FISH DIET
1990 **WWW.GAVINEVANS.COM** / **BORKOWSKI PR**

A classic "what the fuck" photo, this is also a brilliant
example of life mimicking art. Photographer Gavin
Evans was sent to capture an image of a fish-
throwing act (which incidentally featured an ex-*Vogue*
photographer who'd run away with the circus). Stuck
for a workable angle, Gavin stuffed a fish in the
performer's mouth. Archaos immediately made the
stunt the grand finale to their routine.

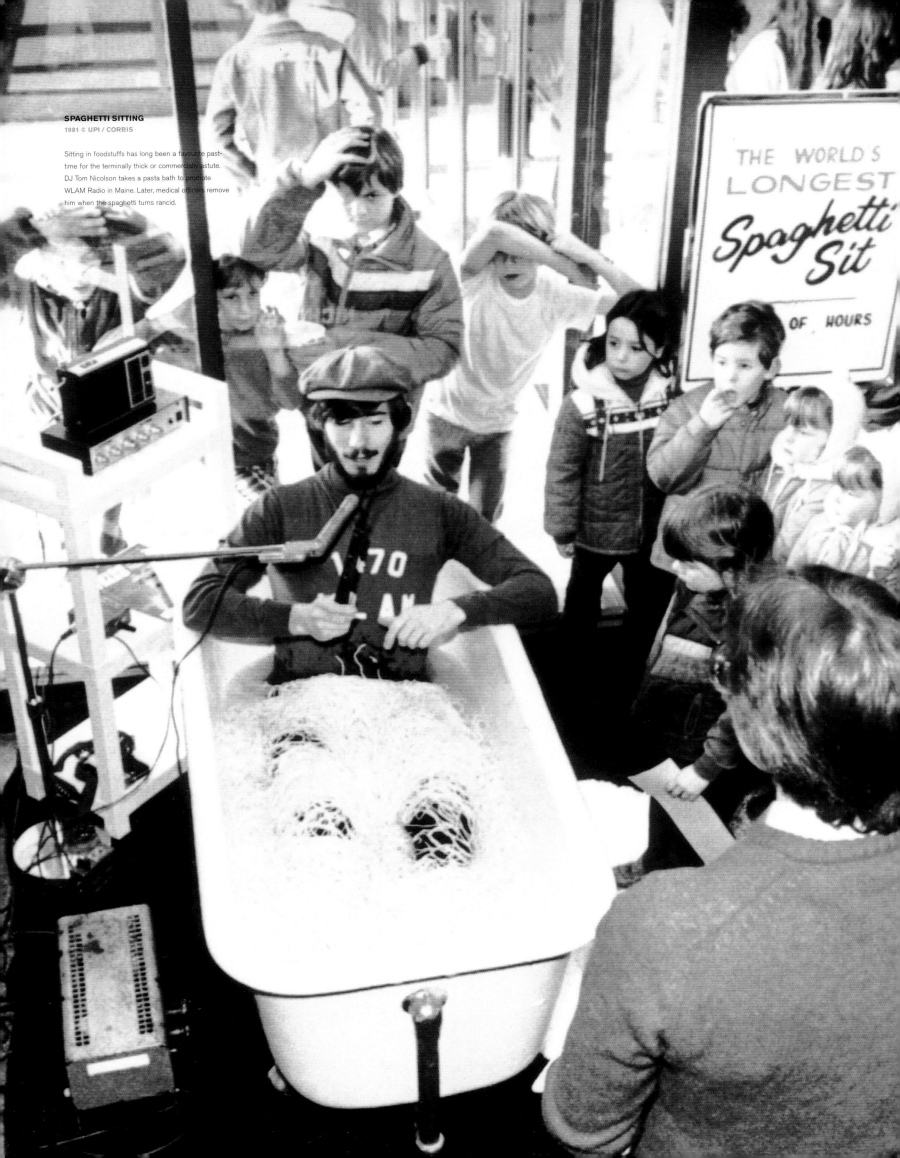

SPAGHETTI SITTING

1981 © UPI / CORBIS

Sitting in foodstuffs has long been a favourite past-time for the terminally thick or commercially astute. DJ Tom Nicolson takes a pasta bath to promote WLAM Radio in Maine. Later, medical officers remove him when the spaghetti turns rancid.

THE WORLD'S LONGEST *Spaghetti Sit* OF HOURS

4 | RECORDS...

ANY PUNTER CAN SEE THAT CATHERINE JUNG, LONNY THE CHIMP, JOSIE LOPEZ AND DIANE WITT REPRESENT HOT PR PICKINGS WITH OBVIOUS COMMERCIAL APPLICATIONS. JUNG HAS THE WORLD'S SMALLEST WAIST, LONNY IS DEEMED THE MOST ADROIT HANDLER OF HACKSAWS AND OTHER DIY APPLIANCES IN THE WORLD, JOSIE LOPEZ HAS THREE FEET, AND DIANE WITT IS THE PROUD POSSESSOR OF THE LONGEST HAIR ON THE PLANET.

F or the publicist suffering from lack of inspiration, a copy of *The Guinness Book of World Records* is a vital resource. Whether it's the largest, the longest, the smallest, the tallest, or any other quantitative absurdity, people are fascinated by record attempts and the bizarre images they engender.

At a party in 1951, Guinness chairman Sir Hugh Beaver became involved in a friendly argument about the fastest flying game bird in the world. His host's library could cast no light on the matter. Sir Hugh spotted a gap in the market and made a call to a research agency run by Ross and Norris McWhirter, asking if they would like to write a book as a reference source which could resolve such issues.

The first edition of *The Guinness Book* was published in 1955. Nearly half a century later, the book has sold upwards of 84 million copies, in 77 different countries, and has been translated into 38 different languages. It's outsold both the Bible and the Koran. The religion of record-breaking is universal.

The media would be foolish not to cater to such a public appetite - an appetite, of course, which every journalist, photographer and editor shares. The success of the book has served only to formalise a well-established trick used by publicists from PT Barnum onwards. Whether packaged as a contest, a competition or a set-up photo opportunity, record-breaking attempts are events ready-made with anecdotal stories which keep the copy coming.

It's not an advanced science. But the best attempts are built of the kind of creativity which makes media attendance an absolute must.

GIANT APPLE PIE

This gourmet stunt involves a ten-ton apple pie created by bakers at the Orleans County Fair in Knowlesville, New York.

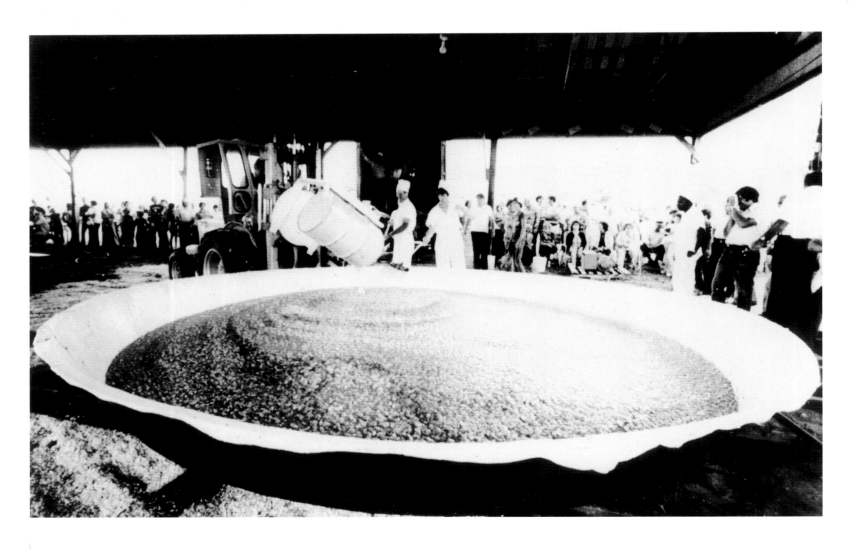

RECORD EATING

1938 © **HULTON GETTY PICTURE COLLECTION**

In 1938, this was an irresistible opportunity for a weak pun. The record served as entrée, followed by a main course of light bulbs, which were washed down with a bottle.

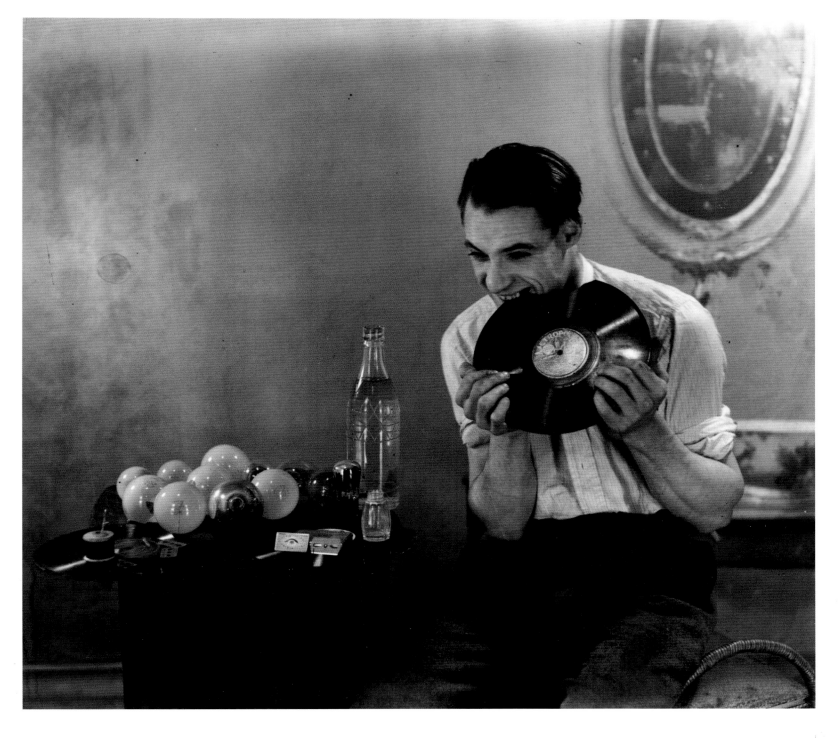

LONGEST CAR

1990 COURTESY OF GERRY COTTLE CIRCUS
ARCHIVE

Shipped into the UK from Finland by Gerry Cottle to
promote a circus carnival scheme, this is officially
the world's longest car. An 'automotive development
project' equipped with a Jacuzzi, it anticipated the
People Carrier concept as well as the health club
boom by some years.

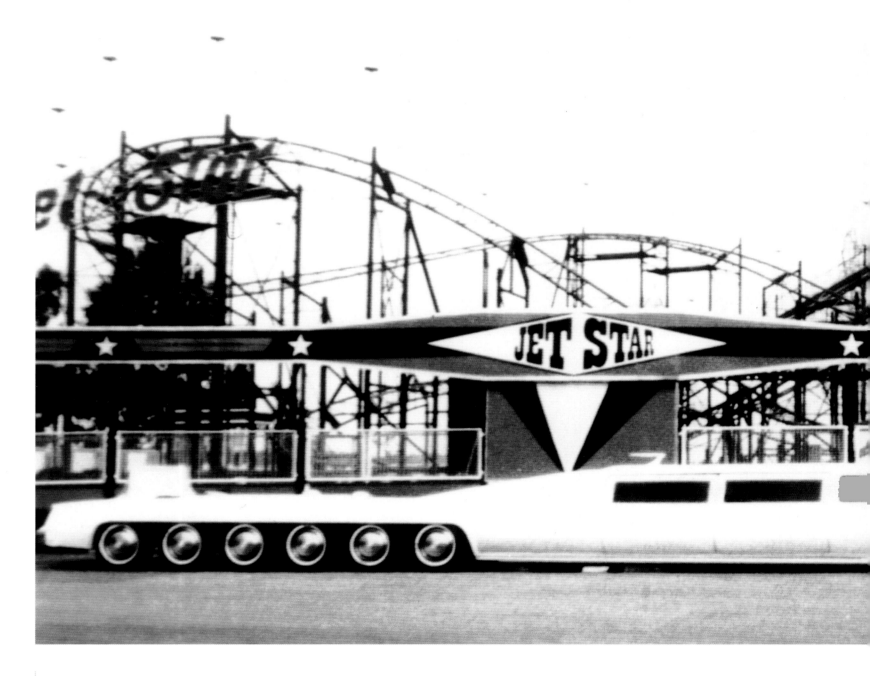

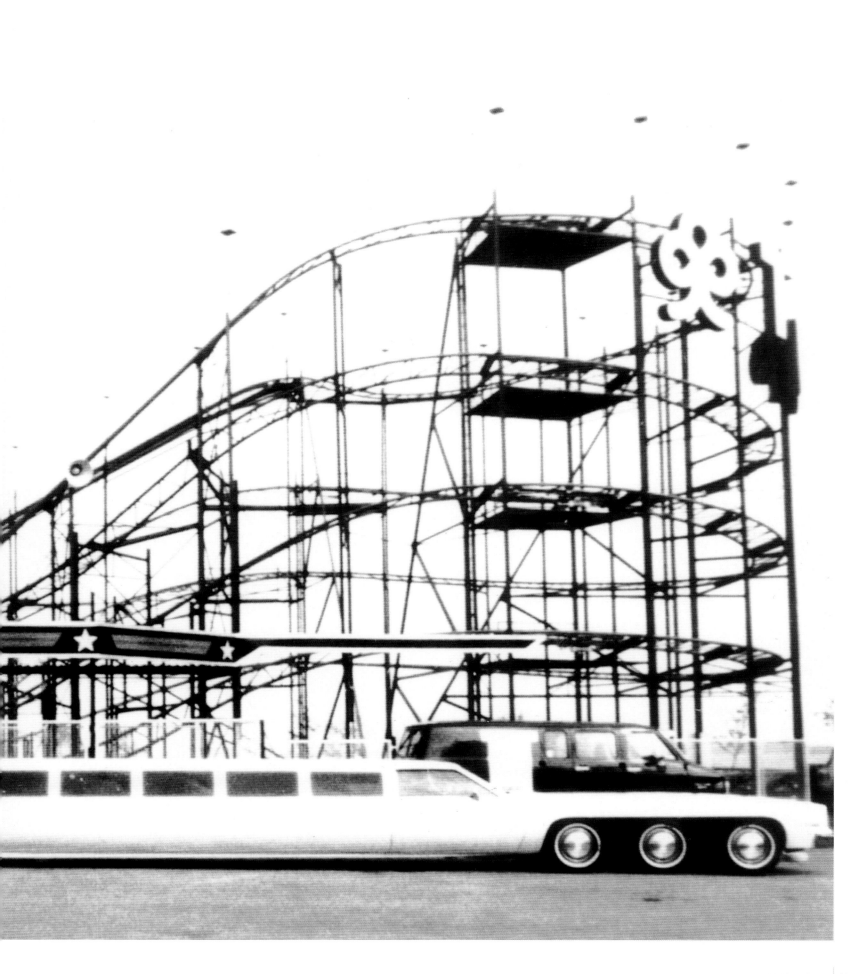

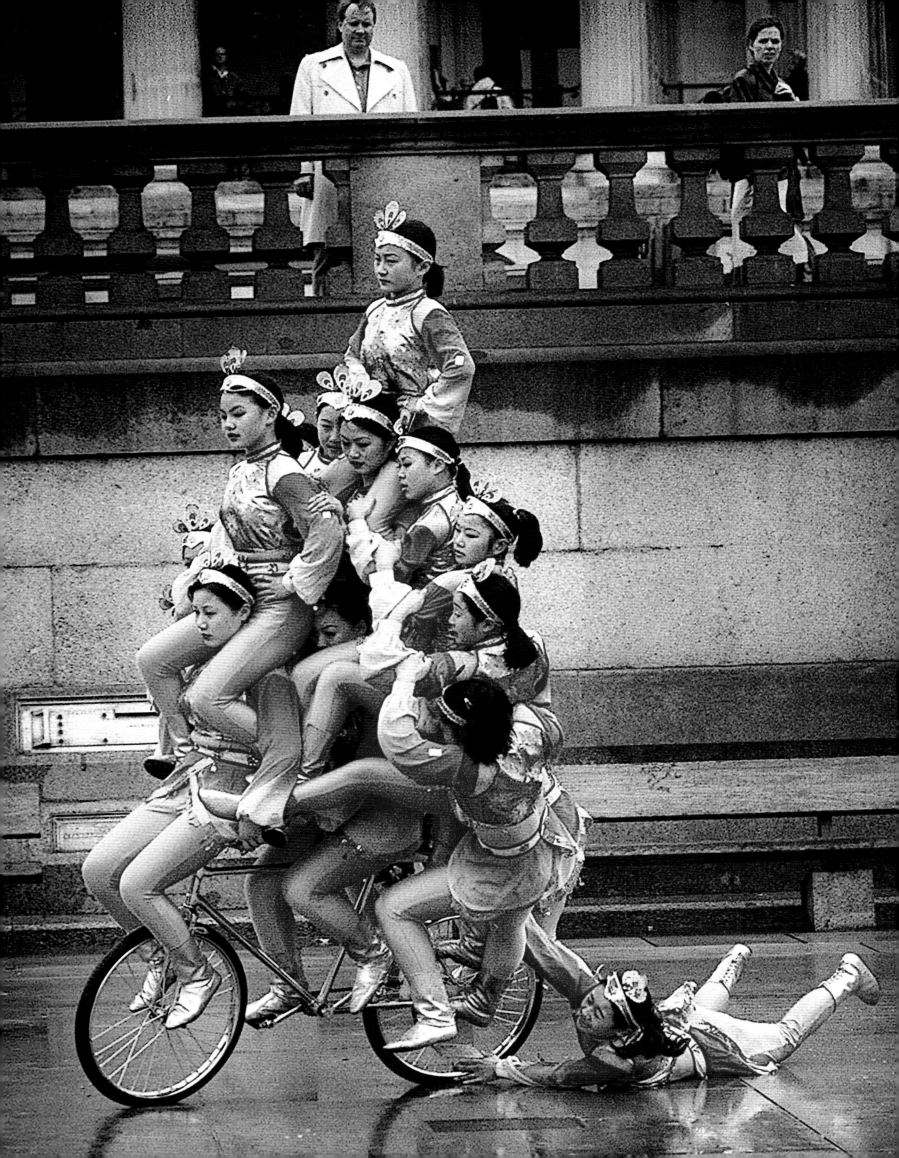

PYRAMID CONSTRUCTION

1965 Ⓒ HULTON GETTY PICTURE COLLECTION

Paris, 1965: these ten acrobats make an early
attempt to cut the cost of cycling.

BIGGER PYRAMID CONSTRUCTION

2000 TOM PILSTON Ⓒ THE INDEPENDENT /
BORKOWSKI PR

Thirty-five years later, technology has moved on
apace. This time, the stunt features no less than
fourteen and a half performers from the Chinese
State Circus.

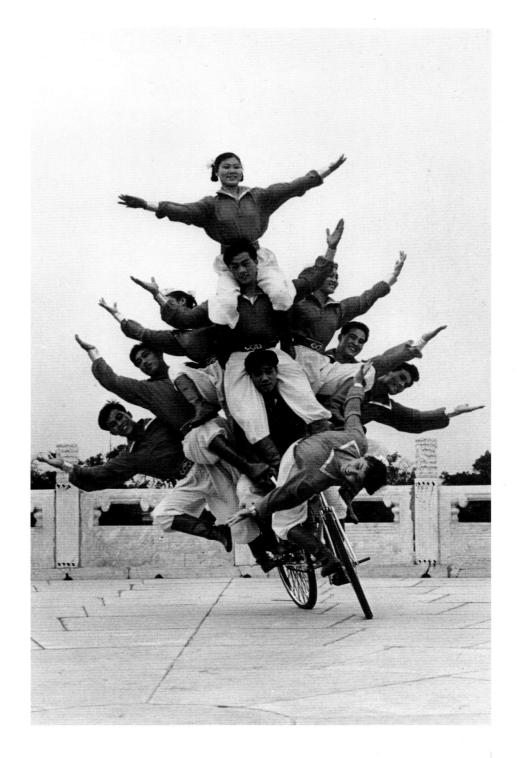

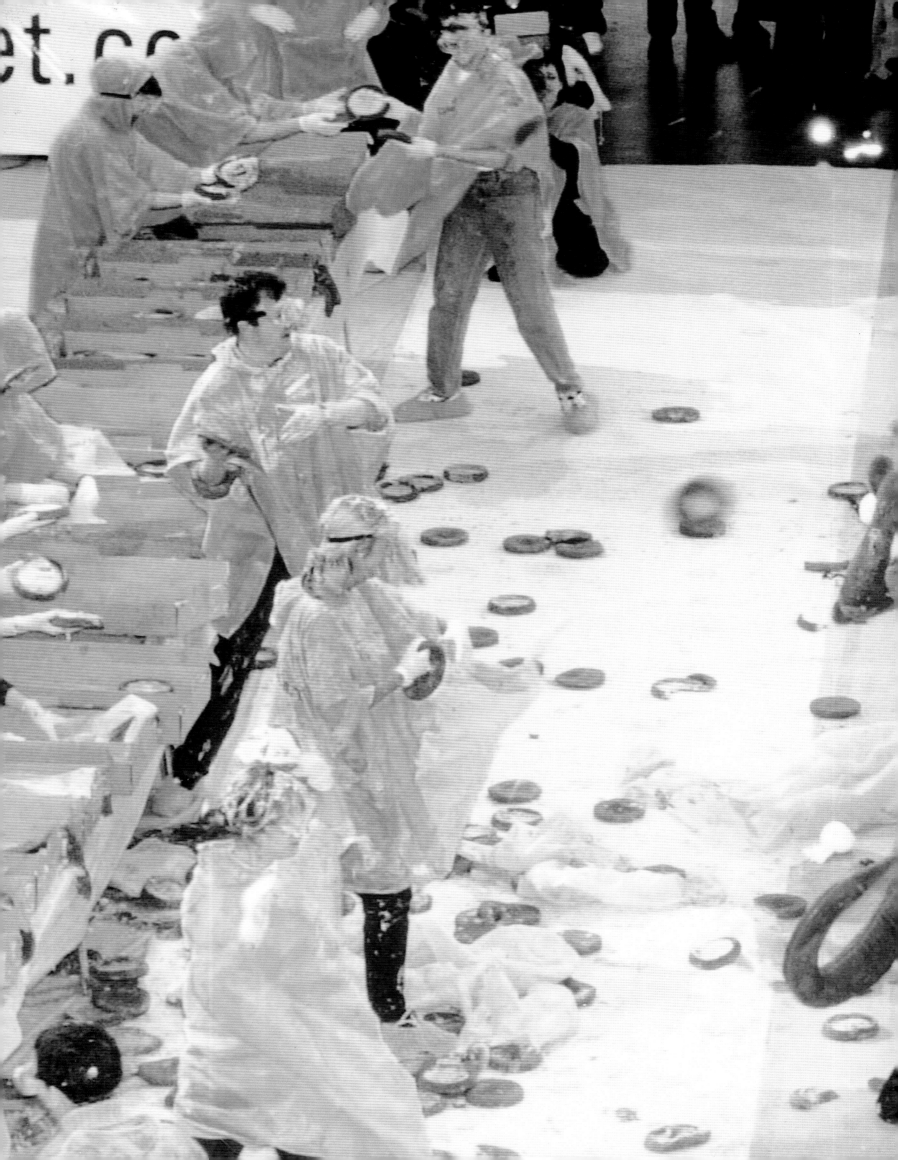

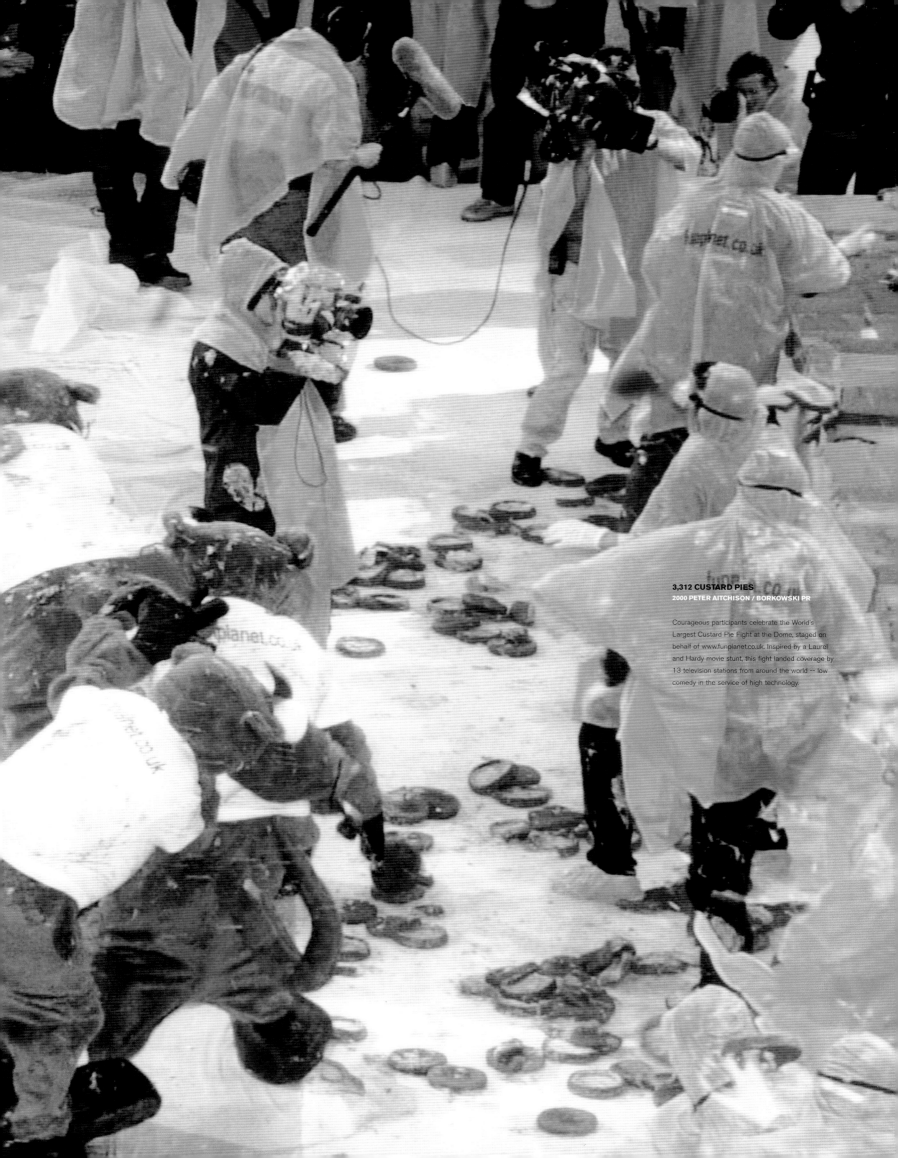

3,312 CUSTARD PIES
2000 PETER AITCHISON / BORKOWSKI PR

Courageous participants celebrate the World's
Largest Custard Pie Fight at the Dome, staged on
behalf of www.funplanet.co.uk. Inspired by a Laurel
and Hardy movie stunt, this fight landed coverage by
13 television stations from around the world -- low
comedy in the service of high technology.

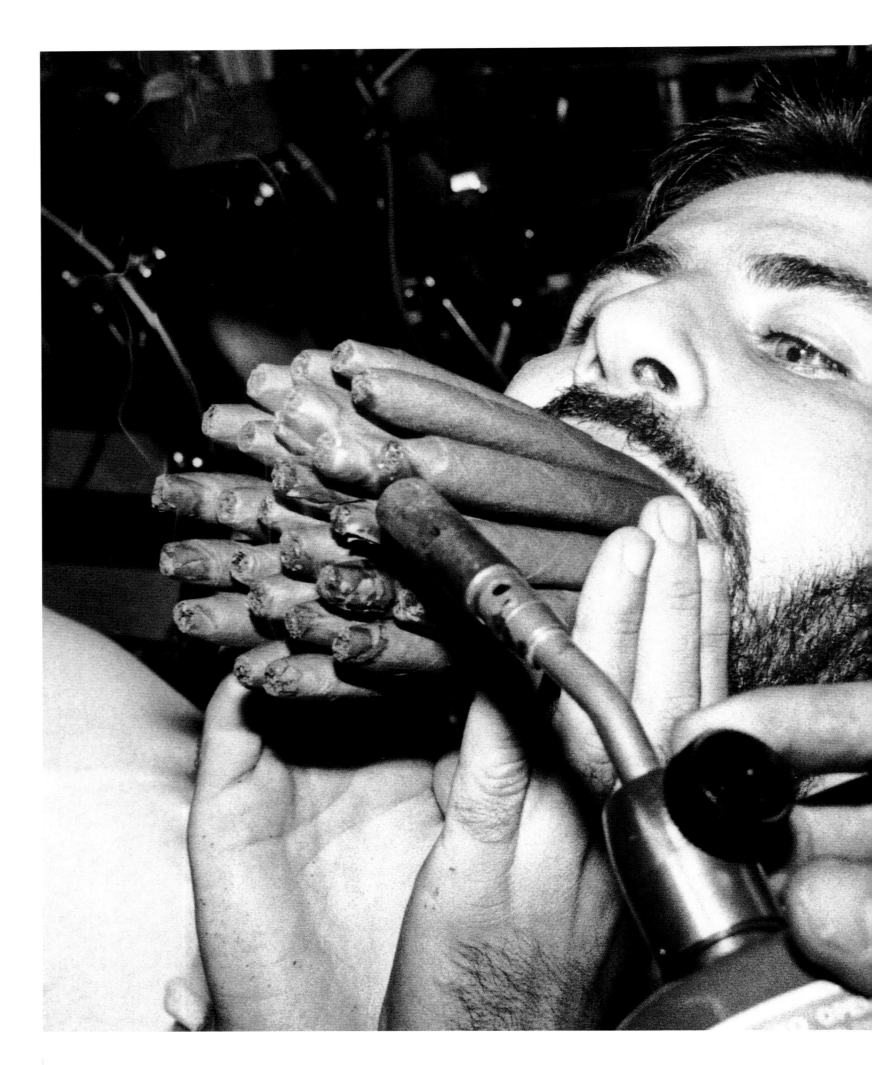

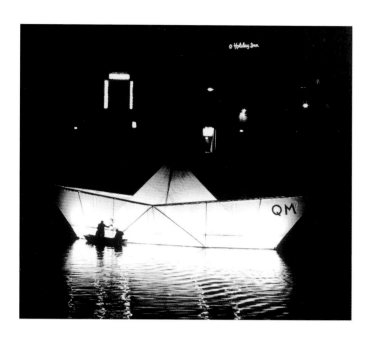

PAPER BOAT BUILDING
1989 BORKOWSKI PR

Scottish artist George Wylie takes to the Thames in the world's largest paper boat. The Holiday Inn branding was fortuitous: the event promoted the Artangel project. It's a striking example of an artist using the media as a canvas for his work.

CIGAR SMOKING
1979 © UPI / CORBIS

Mike Papa, with a blow lamp and 27 cigars, promotes his band Mouth in a record attempt from the 70s.

THE SMALLEST THEATRE IN THE WORLD

SMALLEST THEATRE

1992 DAVID SILLITOE © THE GUARDIAN

The authentically eccentric showman Marcel Steiner prepares for another award-winning performance of his one-man adaptation of *War and Peace*. Mounted on a motorcycle sidecar and replete with state-of-the-art technical facilities and plush velvet seating for one, The Smallest Theatre In The World was – until Marcel's death in 1999 - the only venue in the country with an MOT, and a genuine claim to capacity houses at every single performance.

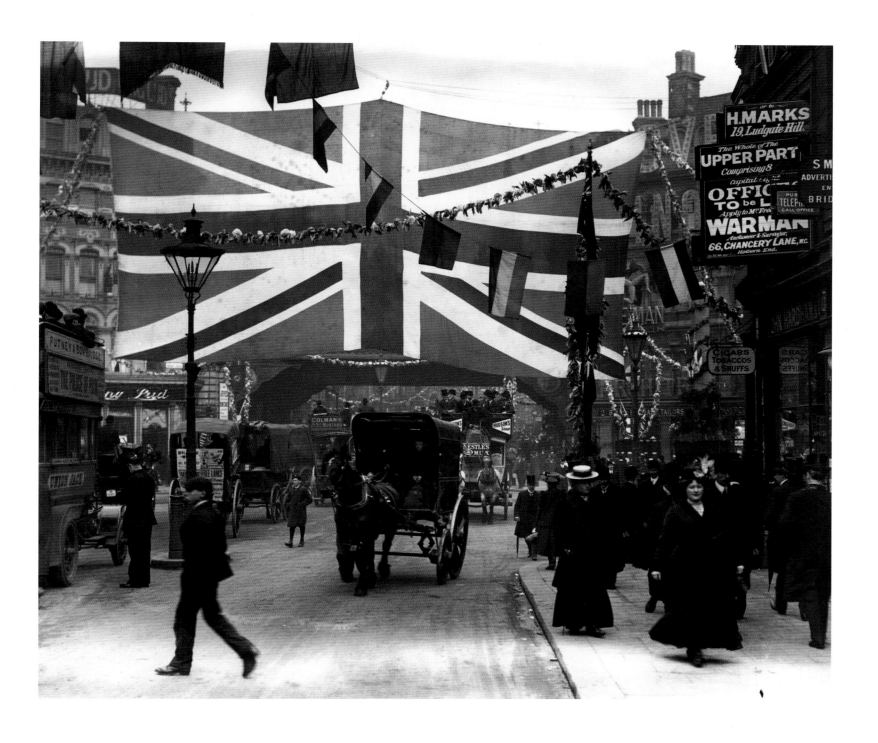

BIGGEST FLAG

1907 © HULTON GETTY PICTURE COLLECTION

The largest flag in the world stretches across Ludgate Circus in London, to celebrate the visit of a colonial premier to the capital in 1907. Of course, the Great British Empire having since shrunk, we'd be seeing pictures of a postage stamp today.

As master of the surreal and self-branded by his
moustache, Dali had an instinct for self-promotion,
cannily developing alter egos to create confusion in
the minds of the press. Taken at a press conference
in Paris in 1973, this twin-headed image makes
doubly sure that the artist's features are unforgettably
impressed on the public mind.

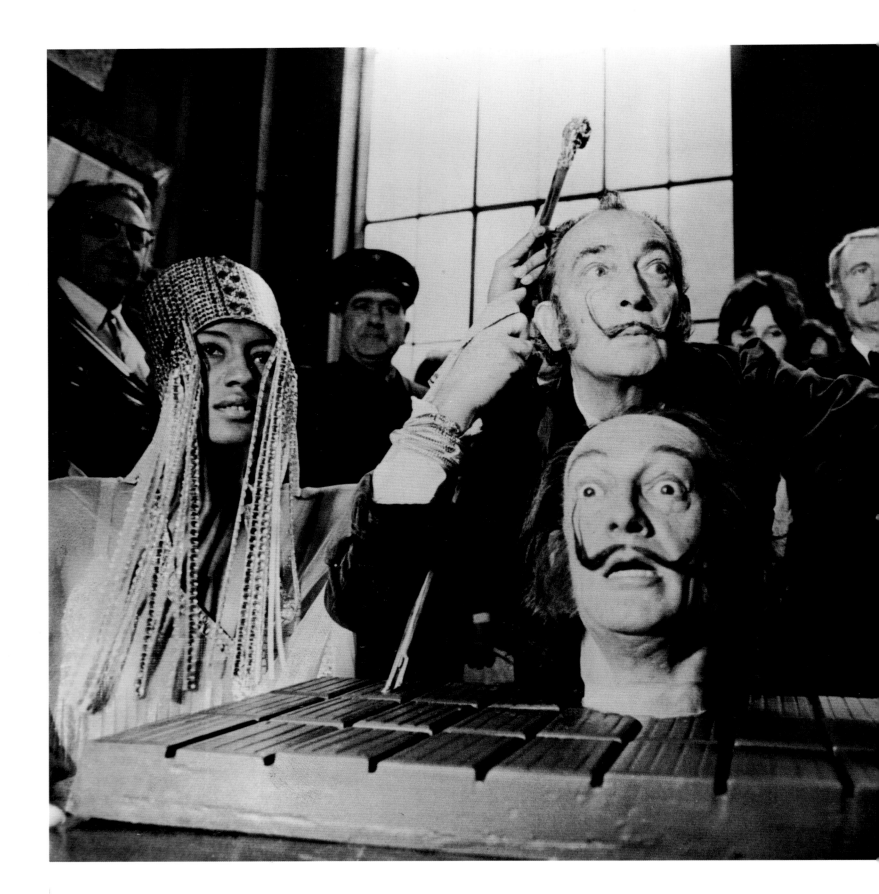

5 | SELF PUBLICISTS...

ANYONE WITH PRETENSIONS TO FAME OR CELEBRITY IS A SELF-PUBLICIST -- OR AT THE VERY LEAST, THEY'RE THE SUBJECTS OF POWERFUL PUBLICITY MACHINES. BUT THERE IS A FAST-GROWING SUB-SPECIES OF MEN AND WOMEN DETERMINED, BY WHATEVER MEANS, TO SEE ITSELF IN PRINT.

Since the media's appetite for sensation is voracious and the number of media outlets is spiralling exponentially, the demand for content is enormous - as are the opportunities for self-publicists, from the complete amateur to the hardened professional.

From fly-on-the-wall documentaries to daytime angstravaganzas, the public has rapidly learnt that it possesses a marketable resource. Though we may not know it, we're now adept at the art of packaging ourselves for media consumption. It's said that of four Americans pulled off the street at random, it's nearly certain one will have appeared on television. Warhol was right about fifteen minutes of fame — almost. The currency has devalued, and we now trade in thirty-second sound-bites of celebrity.

Take the case of Mr Marmaduke Arundel Wetherell, as recorded by James Langton in the *Sunday Telegraph* in 1994[6]. The story's veracity is difficult to gauge, but at least it was printed on 13 March rather than 1 April. Langton's tale was uncovered by David Martin (a zoologist with the Loch Ness and Morar scientific project) and Alastair Boyd, a fellow researcher.

Duke Wetherell was an actor, film producer, big game hunter and self-publicist, hired by the *Daily Mail* in the spring of 1933 to track down the Loch Ness Monster and scoop their rivals at the *Daily Express*. Duke had already shown his skills in the PR game with a scam about talking parrots which broke in the media to coincide with the opening of his epic *Robinson Crusoe*. As luck would have it, mere hours after his arrival, the diligent hunter discovered two

huge footprints. With four pads about eight inches across, Duke deduced that he'd stumbled on the tracks of "a very powerful soft-footed (amphibian) about 20 feet long". Plaster casts were taken and sent to the Natural History Museum, who pronounced in January 1934 that they were in fact the prints of a young hippo. The monster was dead.

But later that year, Colonel Robert Wilson - a respectable Cambridge-educated surgeon with a string of sixteen letters after his name — turned up at an Inverness chemist's shop with four photographic plates, one of which was the fateful grainy shot which has fascinated generations of monster mythologists.

To cut a long story short: Duke Wetherell had returned home to Twickenham after the hippo-foot fiasco. The *Mail* was less than happy with him. "They want a monster: we'll give them one," he told his son, who set off to Woolworths and purchased a toy submarine and several tins of plastic wood. Duke's step-son Christian Spurling, a keen model-maker, was commissioned to create the monster. In March, Duke and his son had returned to Loch Ness, taken the shot, and enlisted the aid of a highly respectable friend of a friend to give the picture the cast-iron credibility it required - enter Robert Wilson.

The monster now lies rusting near the shores of Loch Ness. Soon after taking the photograph, a water-bailiff appeared. Duke put his foot out and sank it. Though the monster died, the story never did. Wetherell's desire for celebrity spawned one of the most enduring of contemporary legends. Self-publicity is a strange beast.

KEN LIVINGSTONE

1982 © HULTON GETTY PICTURE COLLECTION

Ever since he ran the Greater London Council in the
80s, Ken Livingstone has had a canny understanding
of personal publicity. He pulled a Branson –
underdog hero fights control freaks – to win the
London Mayoral elections. Back in the halcyon days,
he surveys his kingdom from the Thames.

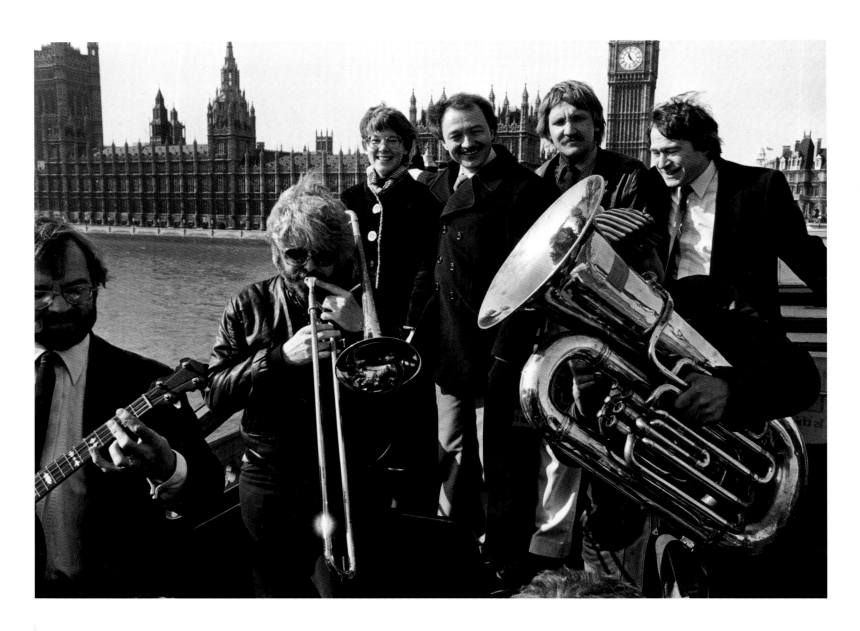

SHMULEY BOTEACH IN BED

1998 CHRIS HARRIS © N I SYNDICATION /
BORKOWSKI PR

The Havana-smoking Shmuley Boteach –
self-appointed radical Rabbinical motor-mouth
and thorn in the flesh of the Jewish establishment –
here jumps into bed with the media to promote a
book of marriage advice, uncontroversially entitled
The Jewish Guide to Adultery.

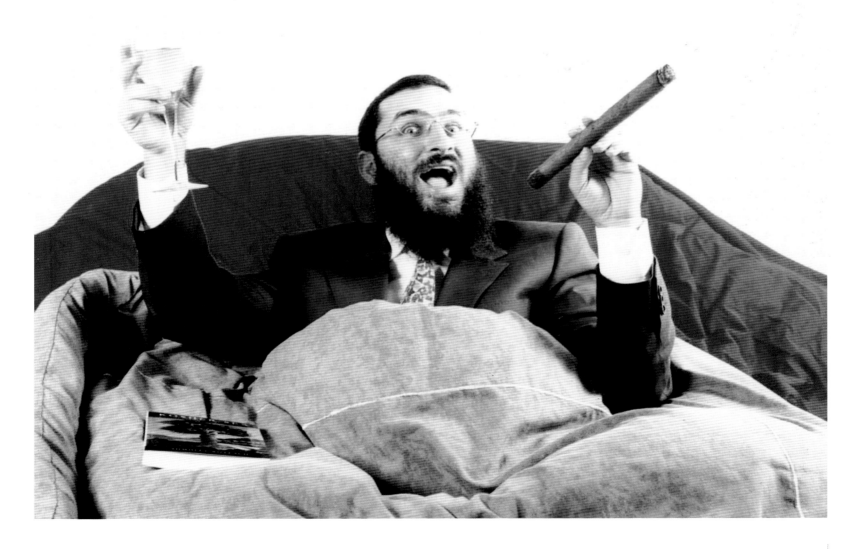

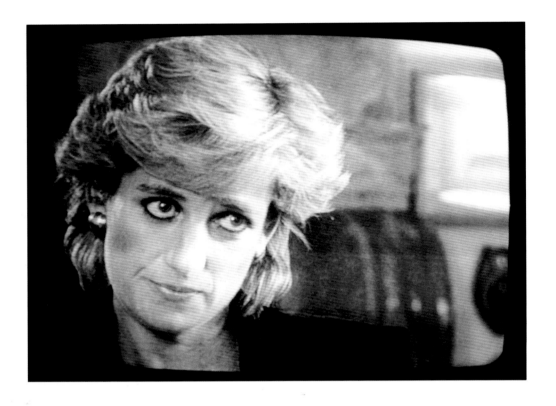

DIANA

1995 EAMONN MCCABE / THE GUARDIAN

In an interview with BBC1's Martin Bashir, Diana,
Princess of Wales, man-handles the media with
touching vulnerability.

ALFRED HITCHCOCK

Hitchcock was a master brand-builder.
His appearance in every film and use of his own
image in promotional stunts were key mechanics
which made his name synonymous with horror and
suspense. In this shot, his dummy floats down the
Thames during the filming of Frenzy.

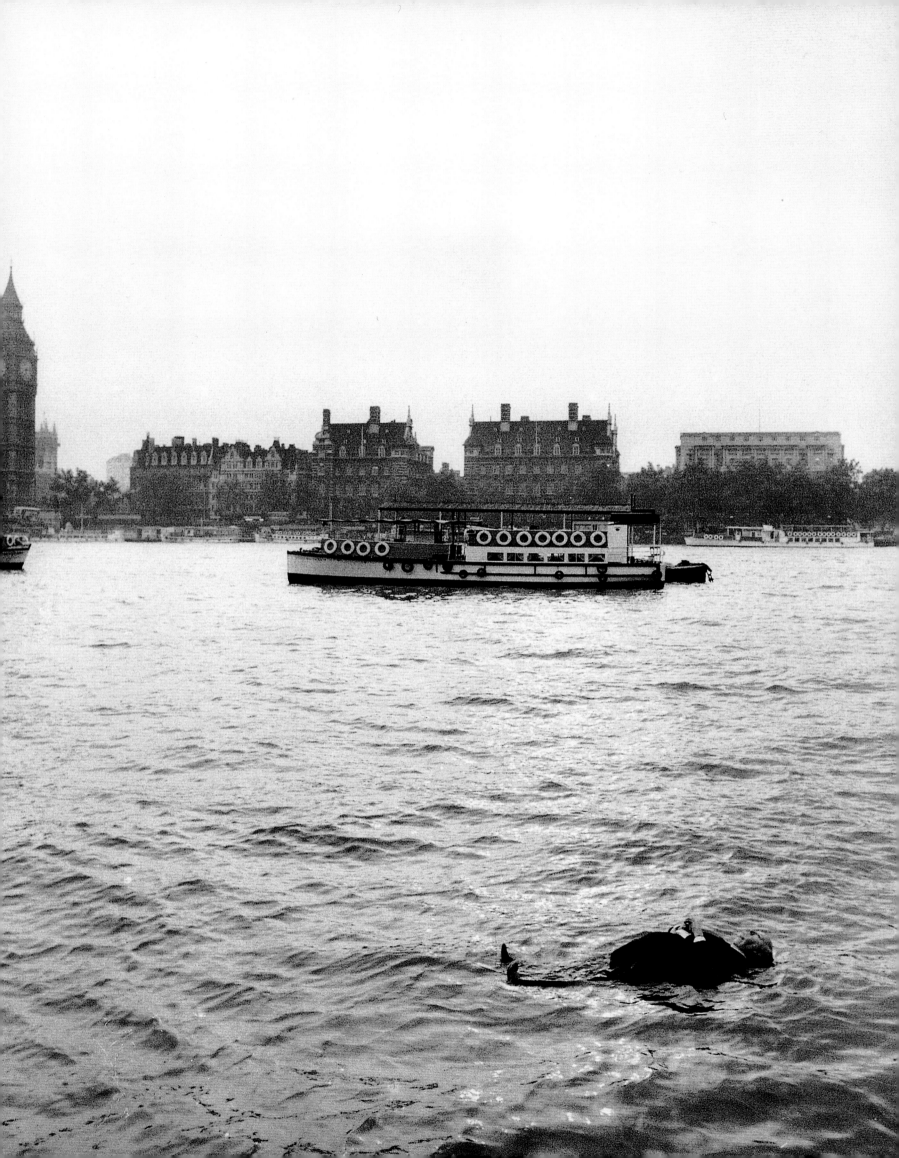

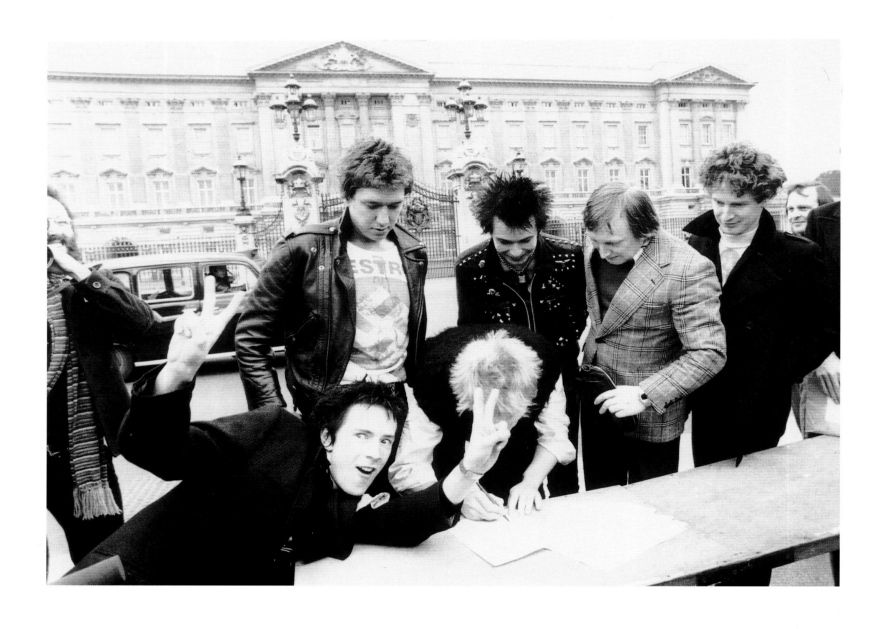

MALCOLM MCLAREN AND THE SEX PISTOLS

1977 RICHARD YOUNG © REX FEATURES

Punk Svengali Malcolm McLaren exploits British establishment sensibilities, opting out of signing the Sex Pistols' record deal in the cloistered calm of a lawyer's office, choosing instead the full glare of the media circus just outside Buckingham Palace.

TONY BLAIR

1997 MARTIN ARGLES © THE GUARDIAN

Chairmen of multinationals, would-be privatisers and
share-dealers pose as ordinary members of the public
to cheer as Tony Blair, humble man of the people,
walks to 10 Downing Street after his election victory.

GERI HALLIWELL

Clever sexual symbolism seems to be the idea as
never-subtle ex-Spice Girl Geri Halliwell slides through
gargantuan spread legs at the 1999 Brit Awards.

PETER STRINGFELLOW

1996 DAVE HOGAN © REX FEATURES

Peter Stringfellow -- what a lad. And the birds
seem to love a bit of cheeky fumbling just as much
as the media.

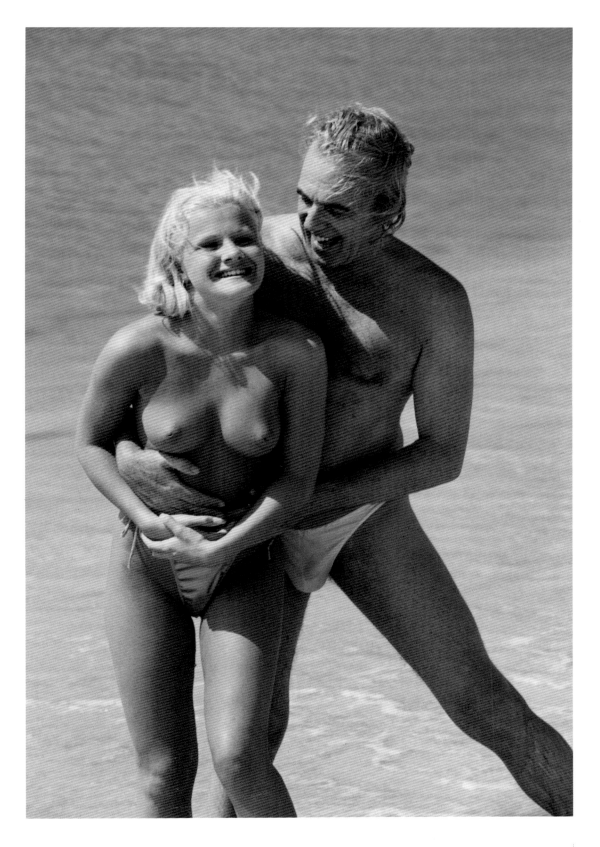

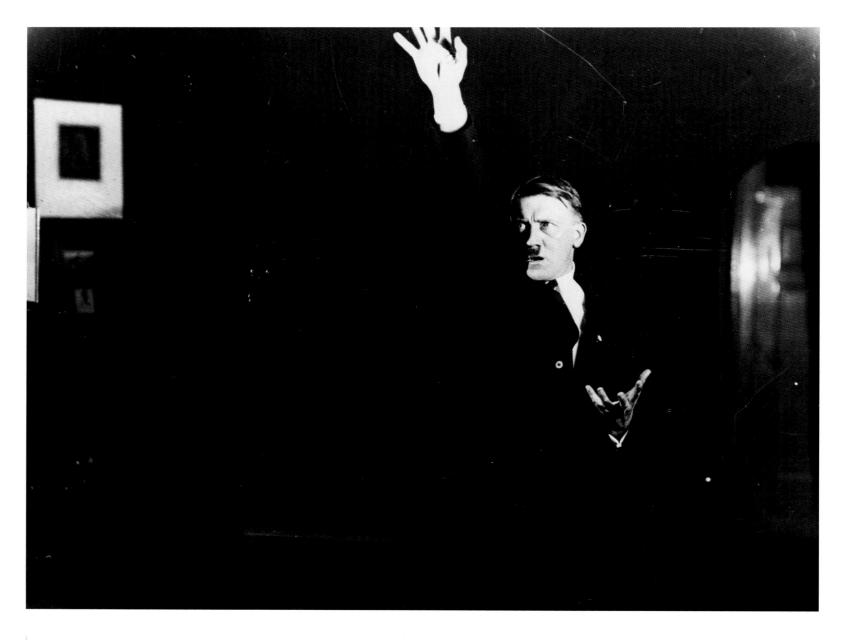

WINSTON CHURCHILL

1942 A A ENGLANDER © HULTON GETTY
PICTURE COLLECTION

Churchill here utilises a blatant photo opportunity
to assert the dogged determination, stern resolve,
and unwavering sense of purpose that is crucial to
the morale of a nation at war.

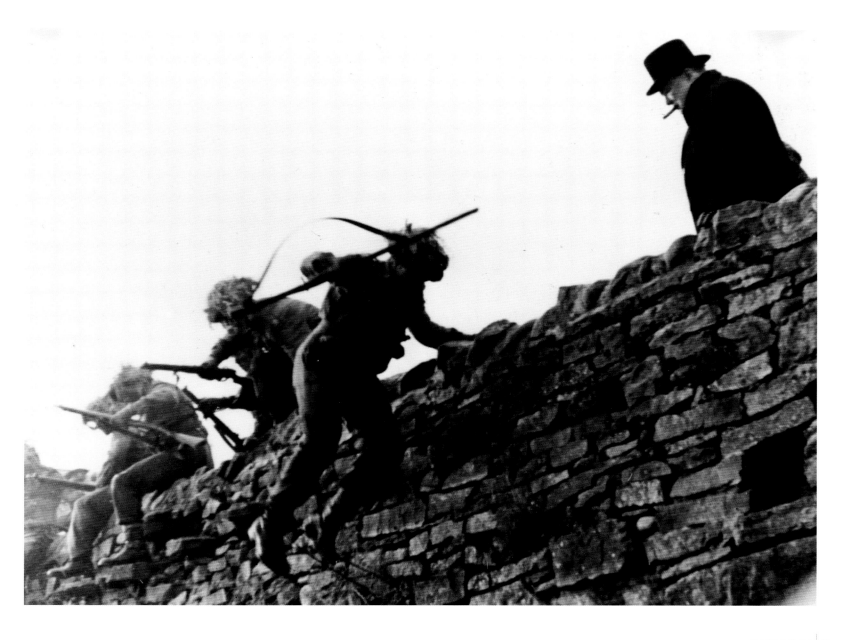

RICHARD BRANSON

Richard Branson is master of the strategic use of self. Whether surrounded by naked women, wearing a wedding dress, or falling out of a balloon, he never fails to further his image as a popular hero and underdog fighting the evils of corporate giants (except, of course, the corporate giants he founded).

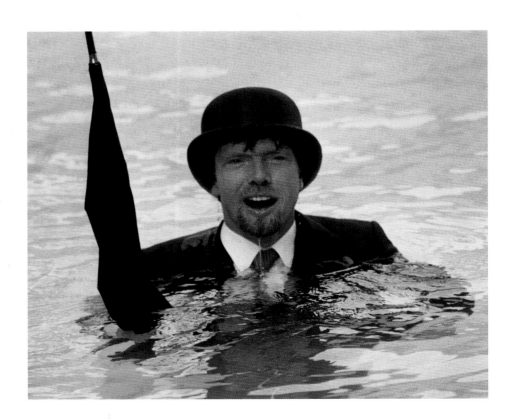

JIM MORAN

Wit and ingenuity characterised every aspect of Jim Moran's PR endeavours, making him a celebrity in his own right. Here he sits, half covered by a cutout of himself, sunbathing in Florida. After a week, he headed off to California to tan the other side. The experiment was meant to resolve a long-running argument between orchestra leader and broadcaster Fred Waring, and his announcer Paul Douglas, concerning the solar powers of the two states. The result was a disappointing draw, but for Waring, his orchestra, the radio station, and Jim Moran, the stunt was a resounding media victory.

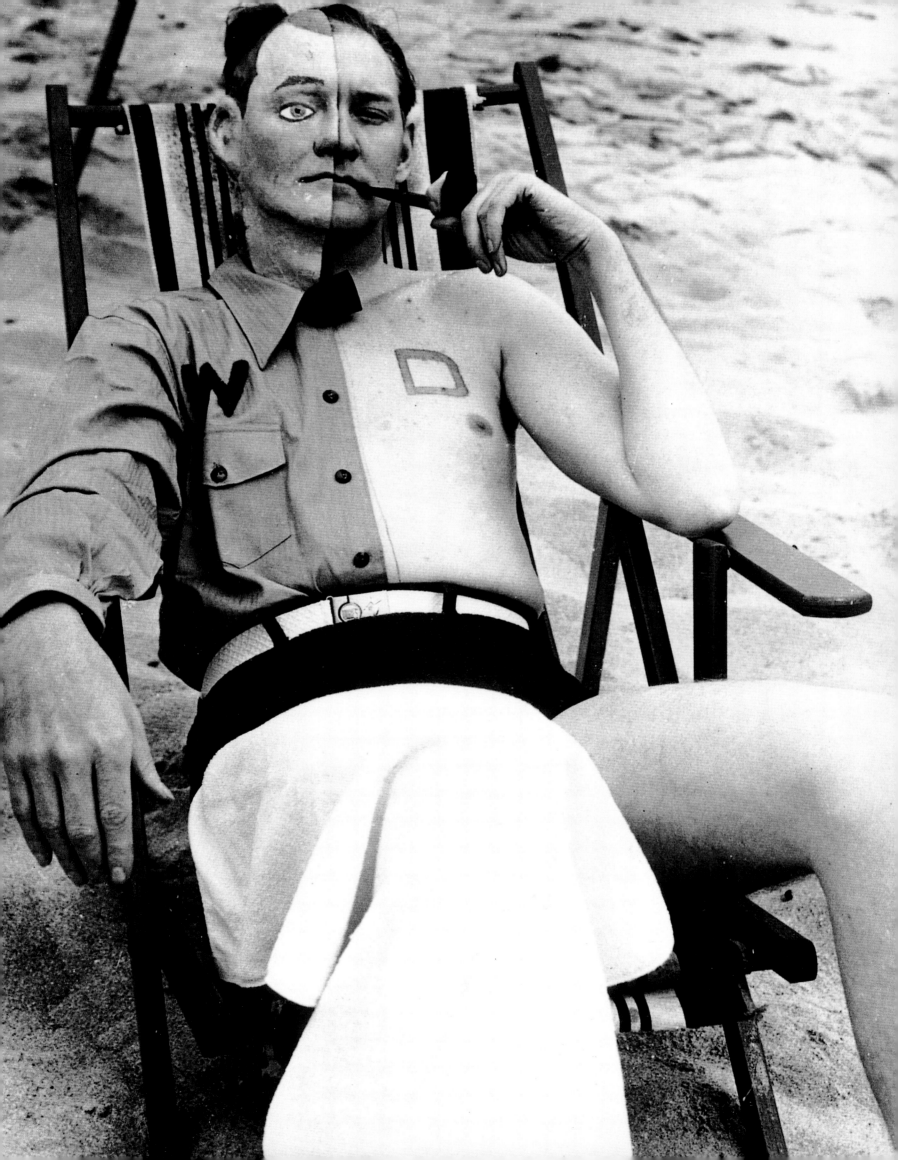

LORD SUTCH

1984 © HULTON GETTY PICTURE COLLECTION

Lord Sutch, one-time pop-star and leader of the
Monster Raving Loony Party, campaigns to lose his
deposit at yet another election. Rumour had it that he
was financed by the Labour Party to foster the
illusion that Great Britain plc is actually a thriving
democratic nation.

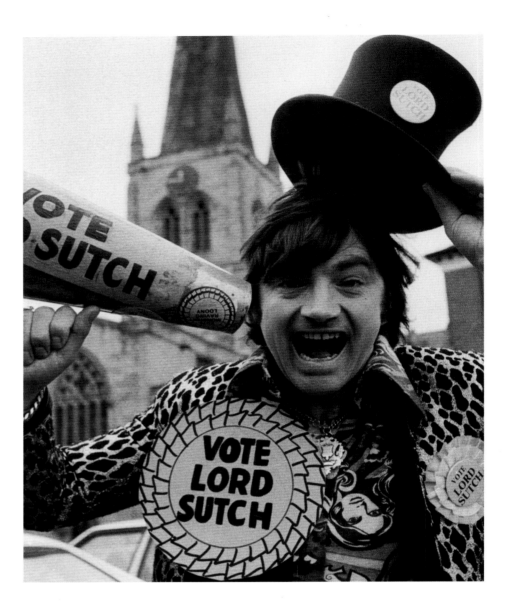

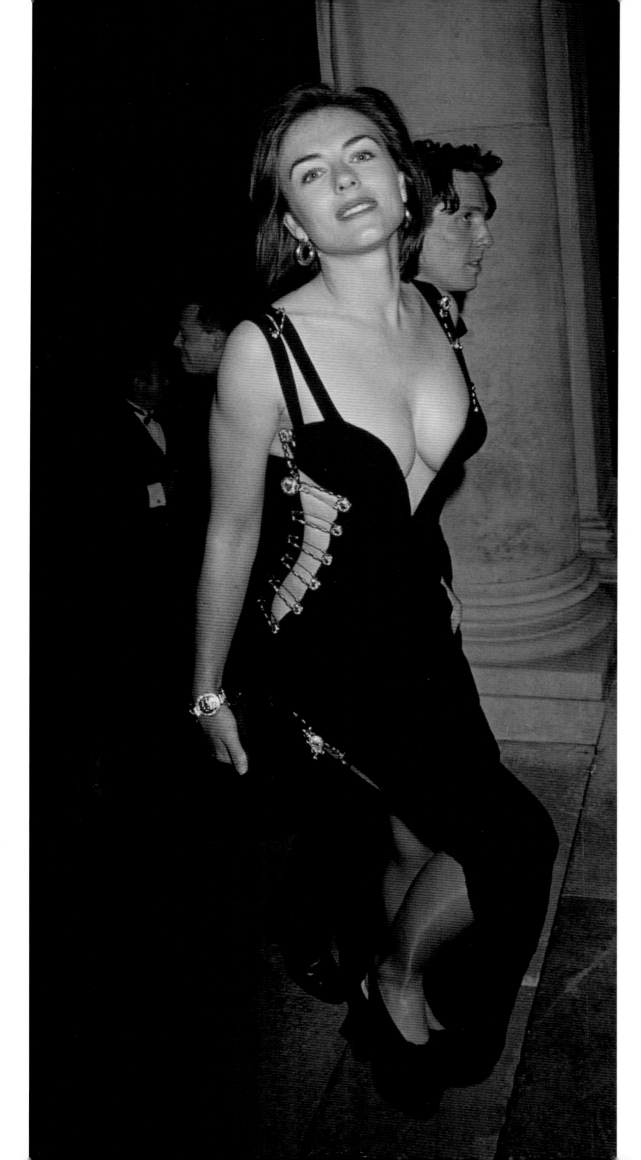

LIZ HURLEY
1994 © DAVE BENNETT / ALPHA PRESS

Dress: Versace. Coat hanger: Liz Hurley.

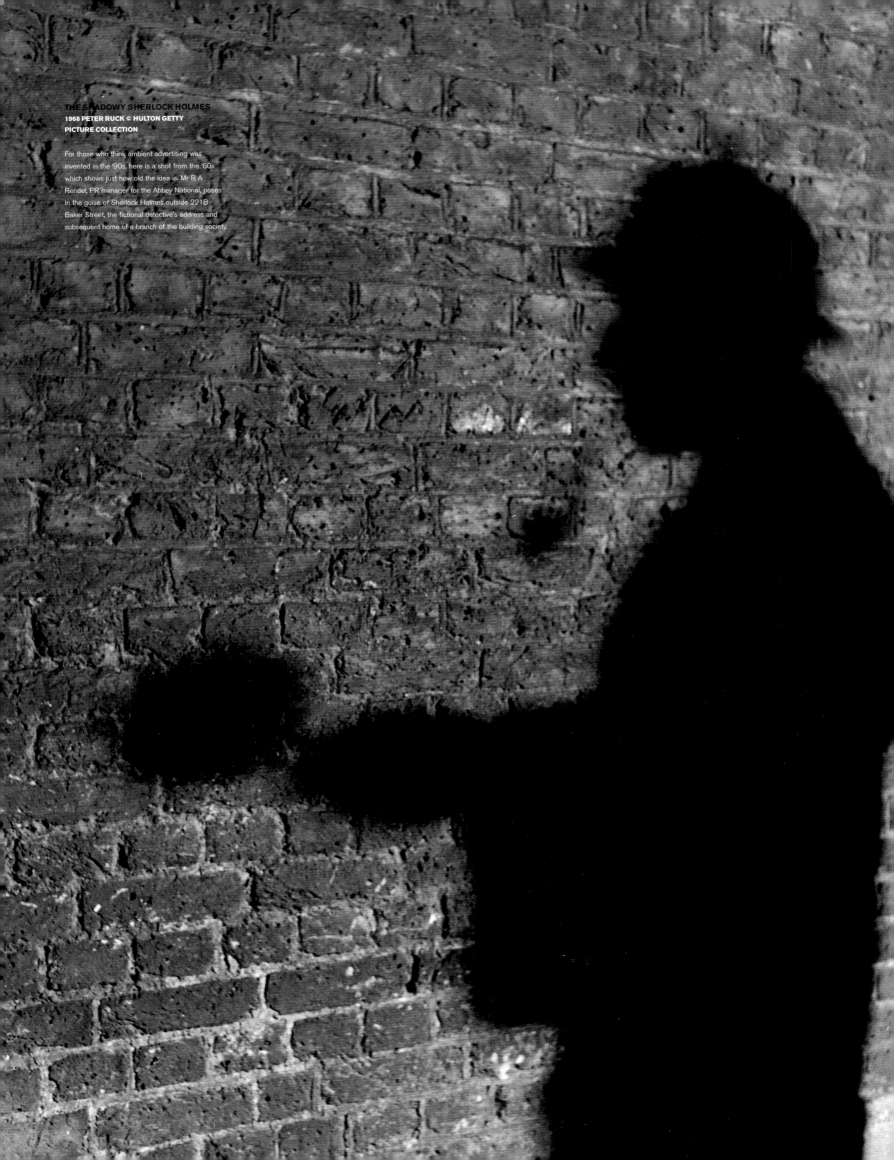

THE SHADOWY SHERLOCK HOLMES
1968 PETER RUCK © HULTON GETTY
PICTURE COLLECTION

For those who think ambient advertising was
invented in the '90s, here is a shot from the '60s
which shows just how old the idea is. Mr R A
Rendel, PR manager for the Abbey National, poses
in the guise of Sherlock Holmes outside 221B
Baker Street, the fictional detective's address and
subsequent home of a branch of the building society.

6 | EVENTS...

A PHOTO OPPORTUNITY IS A MINI-EVENT. IT TRANSFORMS FLAT INFORMATION INTO A THREE-DIMENSIONAL, LIVING, BREATHING ENTITY. AT THE EXTREME, DEVELOPING AN IDEA INTO A FULL-BLOWN HAPPENING GIVES FURTHER BODY TO THE STORY, VALIDATING IT AND EXTENDING ITS LIFE.

In 1993, Mark Borkowski PR was approached by performance artist Dexter Augustus. His CV was not promising. Previous projects included an anti-homelessness 'installation', Dead Man In The Strand, and a dodgy situationist show based on shop-lifting in Somerfields.

He arrived with a hazy idea for a show. Having rented a house in Edinburgh, he was thinking of staging something in the sitting room and was looking for a sponsor. They suggested the name of a current client and sent him on his way, expecting to hear nothing more.

Half an hour later he was back, having hatched a plot at the bus stop to hold a press night to promote the game Taboo, which the company was about to launch for MB Games. It made little sense, and by the time it hit Edinburgh, it made even less. There were ghetto blasters on the roof, semi-naked extras for no apparent reason, guest appearances by Edward Tudor Pole and Judy Balloo (who were sharing the house), and a pre-show barbecue of undercooked sausages served by Dexter riding round the miniscule back garden on a rusty black bike.

All six journalists attending the press night were given a £10 bribe and forced to drink four bottles of Damm before entering the house. Once inside, with the heating on high, an ample supply of over-salted snacks, and another pallet of beer on offer, the audience was totally rat-arsed.

Augustus, in the guise of Charlie Pink, spent a lot of time running round the house shouting nonsensically at Sidney Squeezie. The embarrassing argument finally wound in towards the point of the evening: a game of Taboo, which the drunken press played with a mixture of vociferous alacrity, good spirits and incredible stupidity.

When they showed no sign of leaving, Augustus phoned a mate, who took the names of the journalists attending. Minutes later, the fax phone in the front spit out, "Charles Spencer from the Daily Telegraph: FUCK OFF". The fax was handed over, and Charles dutifully departed. Six times the phone rang, and the room emptied. Outside, a journalist discussed the question "What is art?" with Channel 4; ghetto blasters played Dexter Augustus' theme tune over and over; and the police were summoned by a local resident who claimed the racket was driving him out of his mind.

What all this malarkey meant is open to debate. But over the following months, Taboo secured a level of coverage it could never have achieved on its own. Here, then, is a selection of events large and small, staged as part of similarly dextrous publicity campaigns.

TWIN PEAKS MARATHON
1992 BORKOWSKI PR

It's hardly news when a cult TV series is released on video. However, when all 25 episodes are staged back-to-back in a London cinema, with an audience of 400 carrying pet logs and belting out the theme tune on kazoos, it's well worth half a page of anybody's broadsheet.

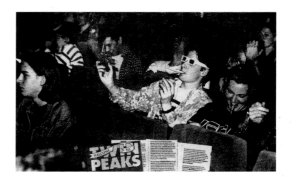

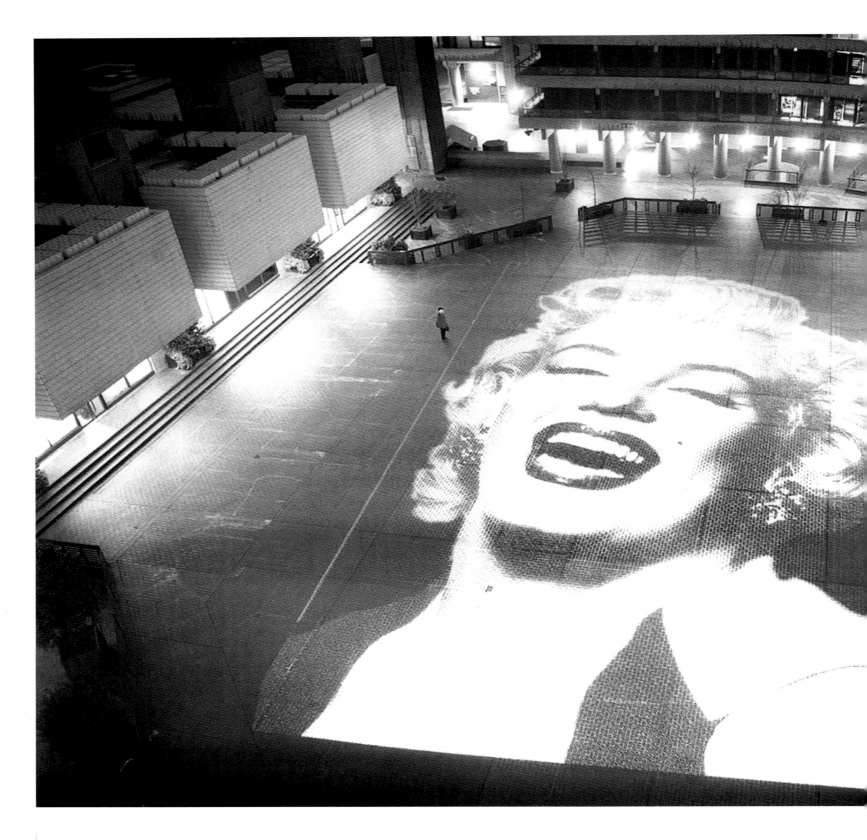

MARILYN MONROE AT THE BARBICAN
1998 RUI XAVIER © THE INDEPENDENT / BORKOWSKI PR

A contemporary example of the light-poster, used to promote a year of US work at the Barbican Centre, was so exquisitely realised that it served as a hugely attractive coverage hook.

PINK STREETS FOR BARBIE'S BIRTHDAY
1997 PAUL BULLEY © CAVENDISH PRESS

This was a great photo opportunity from Beer Davies, with plenty of pre-event controversy and a resoundingly successful final product. Mattel painted Ash Street, Salford pink from top to bottom, to celebrate Barbie's 38th birthday.

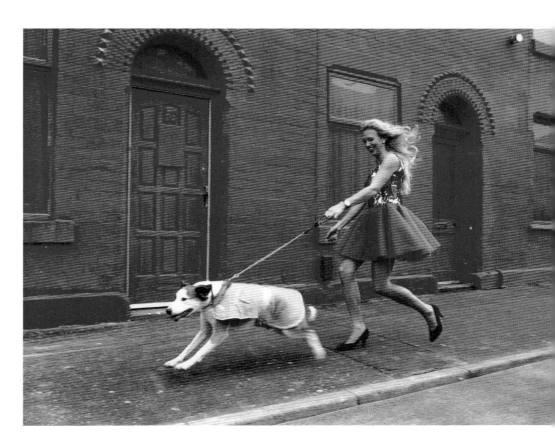

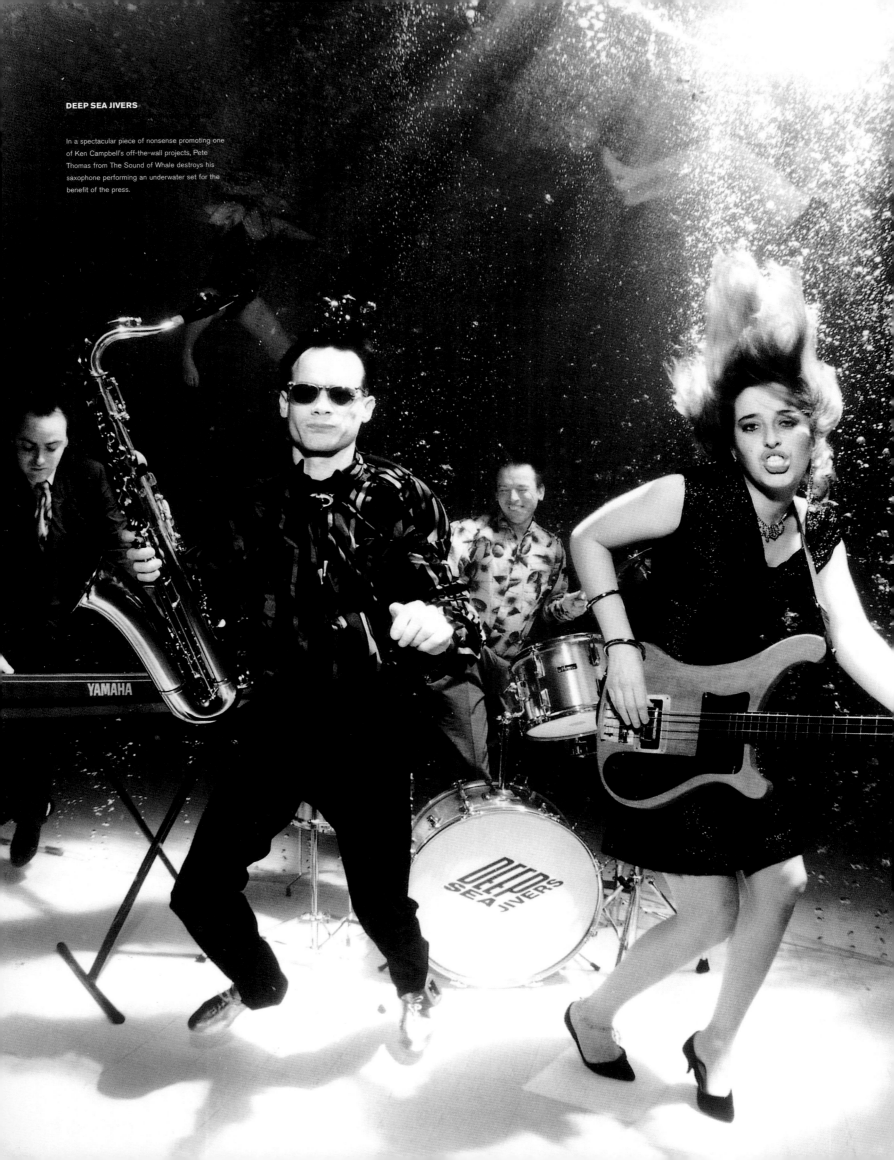

DEEP SEA JIVERS

In a spectacular piece of nonsense promoting one of Ken Campbell's off-the-wall projects, Pete Thomas from The Sound of Whale destroys his saxophone performing an underwater set for the benefit of the press.

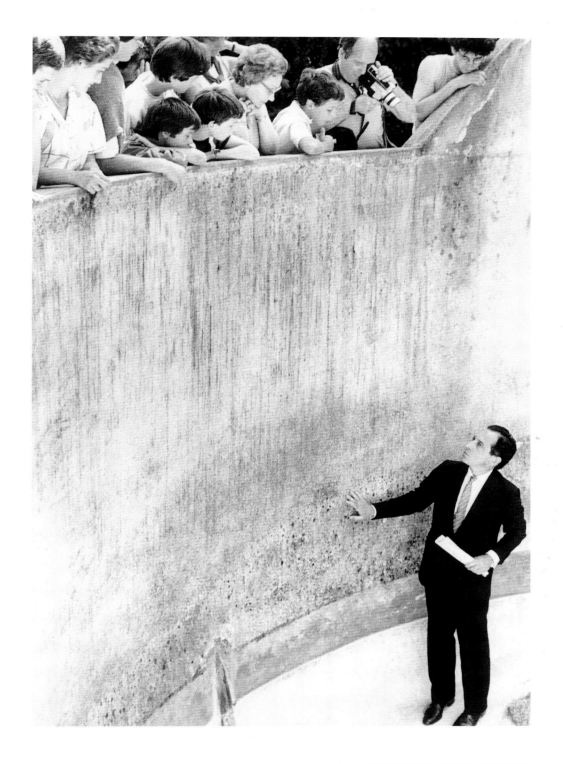

ALBERTO VIDAL - CAGED EXHIBIT

1985 LEOPOLDO SAMSA / MARK BORKOWSKI

Alberto Vidal visits from his native Spain to live as a caged exhibit at London Zoo for a week, where he attracted record attendances and great PR for himself, the Zoo, and the London International Festival of Theatre.

DUMMIES: LIFE-SIZE AND LIVE

1949 GEORGE HALES © HULTON GETTY PICTURE COLLECTION

Two women peer into the window of Peter Robinson's department store, where the mannequins have been replaced by live models. It was a great idea, and bizarre enough to outweigh the nonsensicality of publishing a still photo of the event.

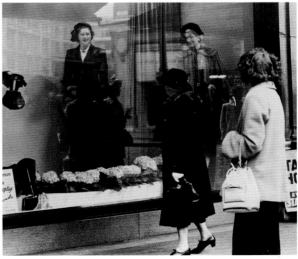

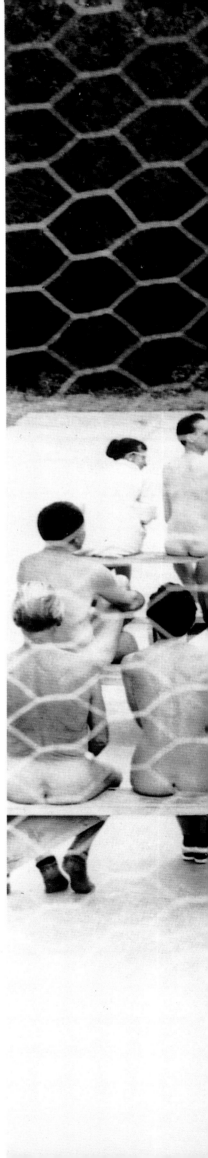

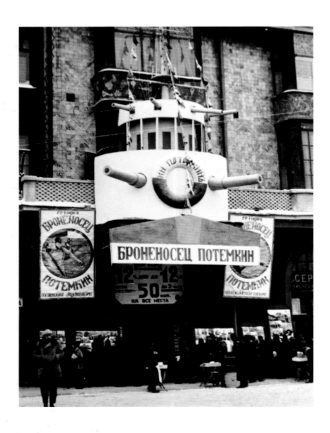

BATTLESHIP POTEMKIN: RUSSIAN HYPE
1925 © HULTON GETTY PICTURE COLLECTION

This oddity shows that whilst Russia may have had
its political propaganda front sorted, the nation's
commercial PR was less convincing. Slowly built
over a period of weeks, presumably by a Bolshevik
Blue Peter presenter out of spare cereal packets,
the stunt generated coverage for the opening of
Battleship Potemkin.

NUDE FILM PREMIERE
1958 © UPI / CORBIS

A silly idea with a touch of sex - perfect media
fodder - is employed here to promote the release
of the movie *Adam and Eve*.

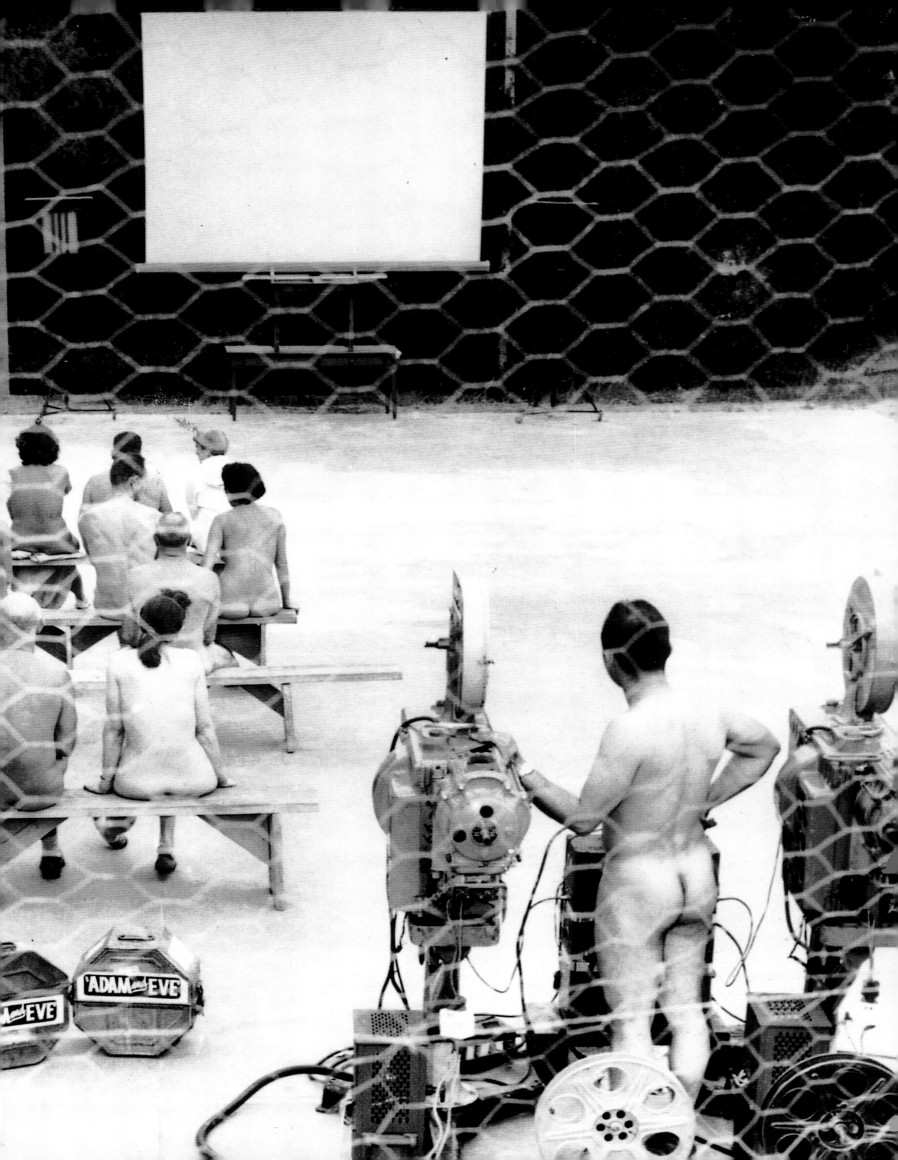

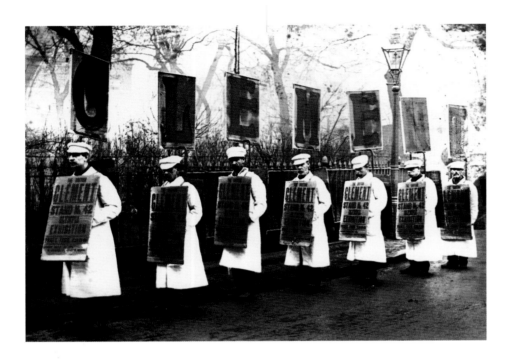

SANDWICH BOARDS FOR CLEMENTS

1908 © HULTON GETTY PICTURE COLLECTION

When you've seen one sandwich board man, you've
seen them all, but when you see seven identically
dressed sandwich board men together, then you have
a photo opportunity. This promotion for the Clement
exhibition stand at Olympia, London, dates from 1908.

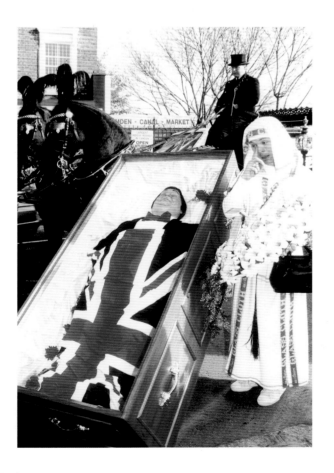

BERNARD MANNING

1992 © NIGEL SUTTON / HAMPSTEAD & HIGHGATE
EXPRESS / BORKOWSKI PR

Drawn by horses on a 100-year-old hearse, the
spitting image of blue comic Bernard Manning is
prepared for an unceremonious dumping in
London's Regent Canal to mark the opening of
Jongleurs Comedy Club and the death of traditional
stand-up. The coffin is accompanied by then-
relatively unknown Graham Norton, disguised as
Mother Theresa of Camden Lock. Unmoved,
Manning tells Norton, "As long as you don't get our
wage packets mixed up, I'm not bothered, love,"
before polishing up a few jokes about the size of his
mother-in-law's arse.

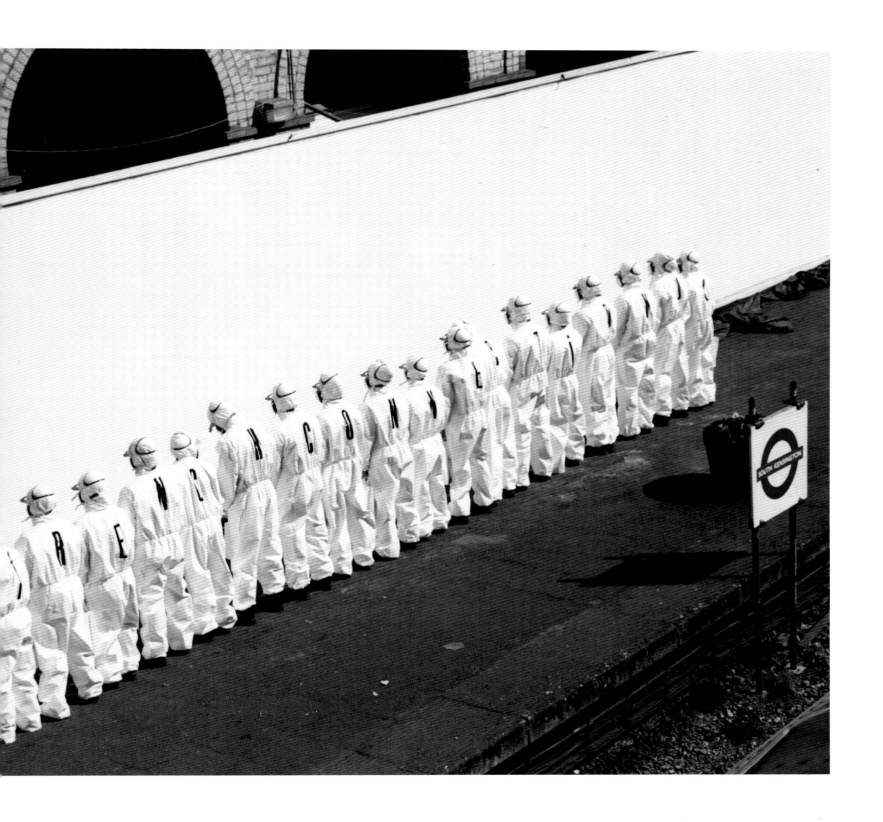

fcuk LAUNCH
1997 ROBERT HIND / BORKOWSKI PR

Exploiting the British horror of the four-letter word,
Trevor Beattie arranged for eighteen radiation-suited
French Connection UK operatives to paste up a
minimalist poster site at a London tube station, then
silently form a line to spell out the company's name.

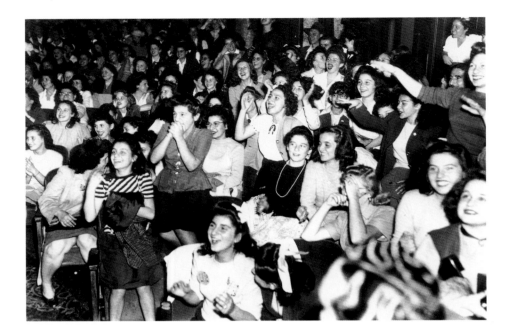

FRANK SINATRA'S FAN CLUB

1944 © CORBIS

Here, Frank Sinatra's early press agent George Evans hires a group of girls at five dollars apiece to squeal with delight whenever the sexy singer rolls a note. Two are trained to fall over in a dead faint. After filling the house with college kids on vacation, tipping off selected columnists and parking an ambulance outside, Evans sat back to observe the pandemonium. The outcome was mass hysteria — and mass media celebrity.

CHARLIE CHAPLINS

1921 © WHATCOM MUSEUM OF HISTORY & ART

For those unclear as to the function of this stunt in Bellingham, Washington in 1921, the information is helpfully printed under the cinema canopy.

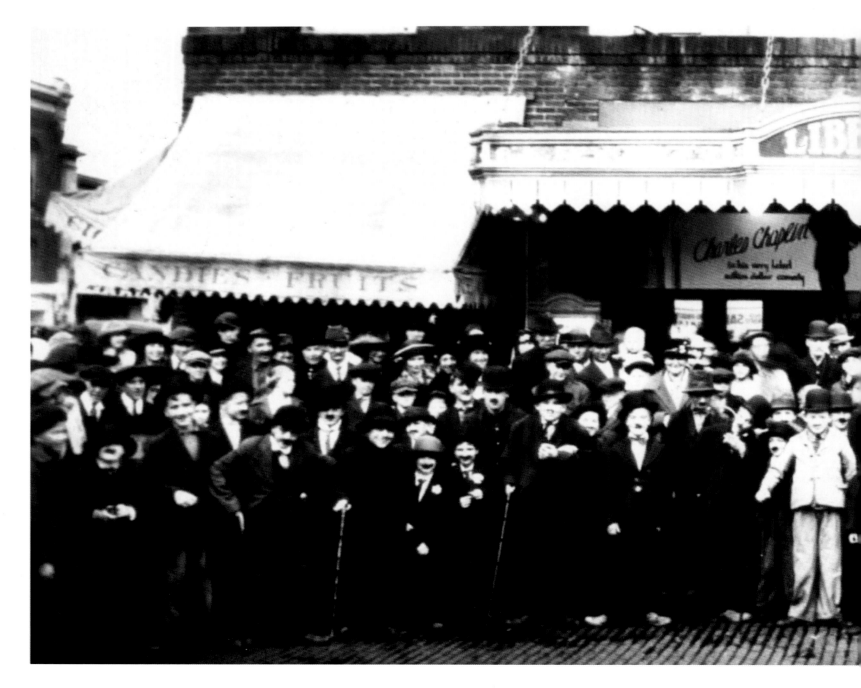

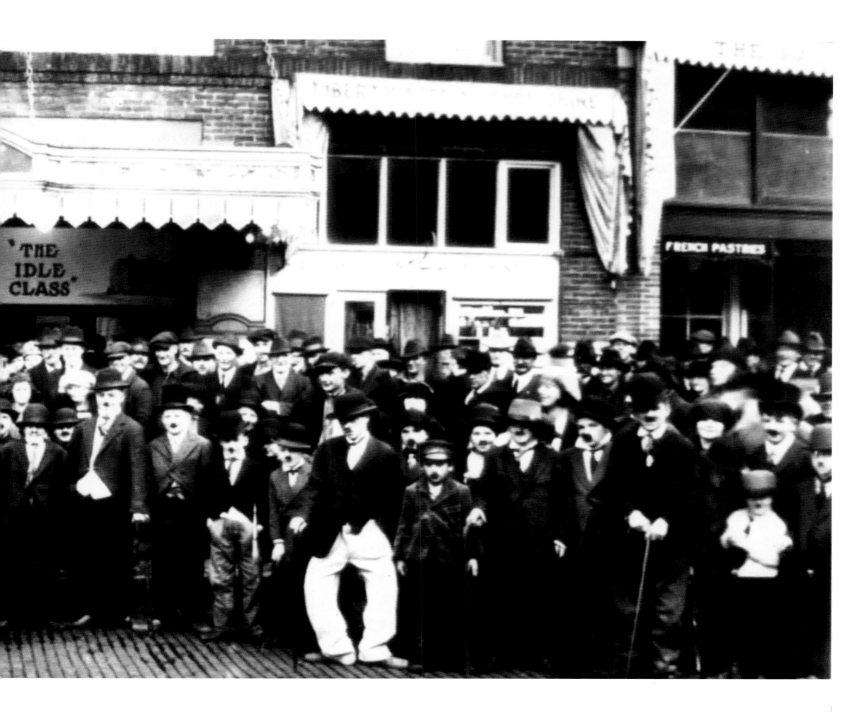

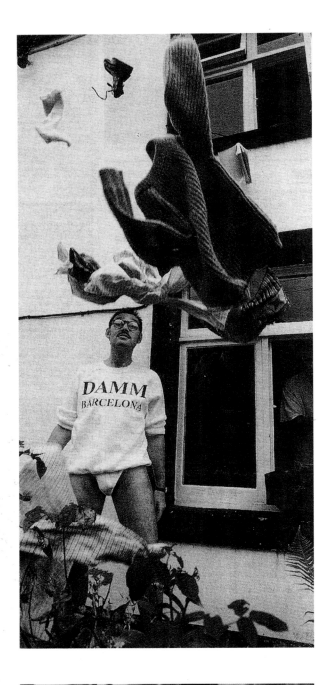

DEXTER AUGUSTUS
1992 PETER MCDIARMID / DAILY TELEGRAPH /
BORKOWSKI PR

All-purpose rent-an-oddity Dexter Augustus
rehearses in his pants for the Edinburgh
spectacular of Taboo.

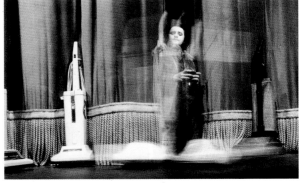

THE HOOVER BALLET
1994 MARTIN ARGLES © THE GUARDIAN

Sheridan Brown showcases yet more performance art
in the service of product. Peculiarly, his radio-
controlled Hoover Ballet was harnessed not in the
service of electrical appliances, but Oranjeboom lager.

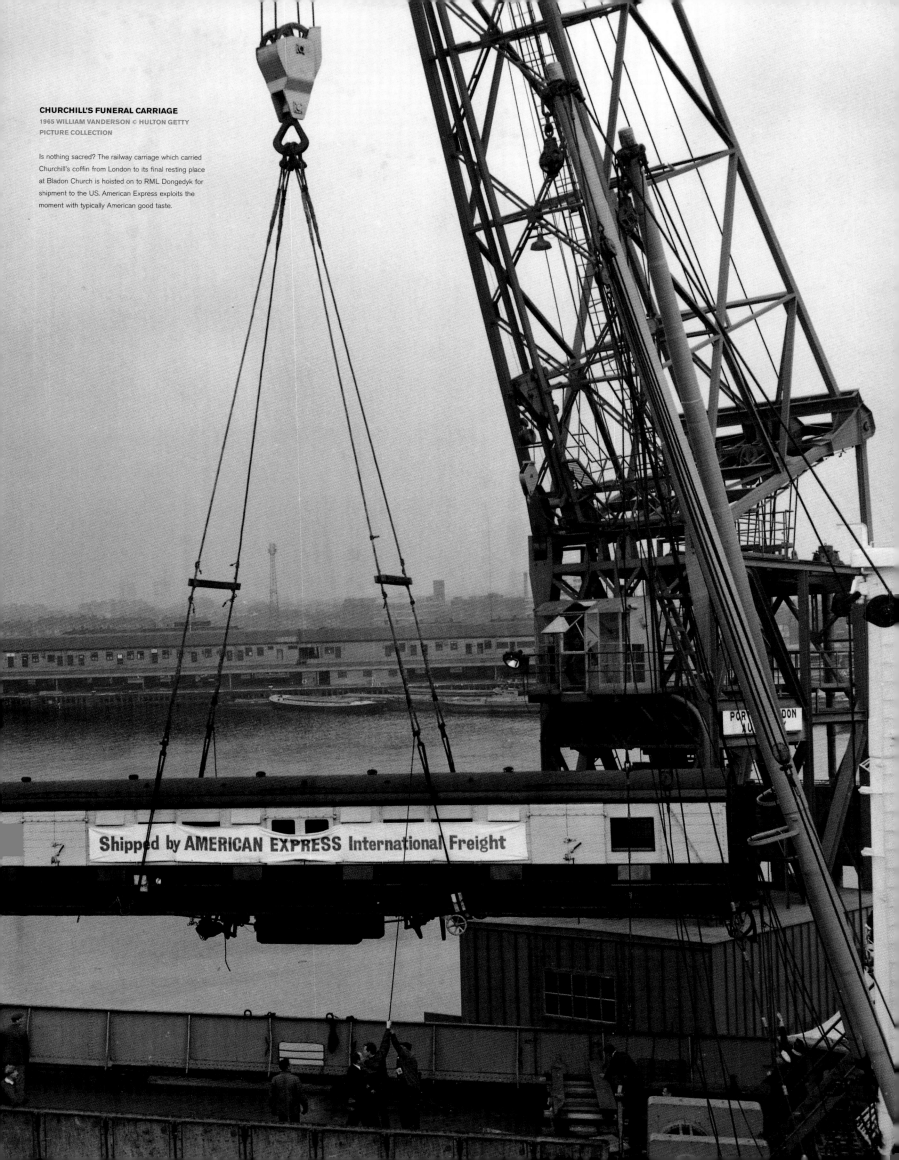

CHURCHILL'S FUNERAL CARRIAGE
1965 WILLIAM VANDERSON © HULTON GETTY
PICTURE COLLECTION

Is nothing sacred? The railway carriage which carried
Churchill's coffin from London to its final resting place
at Bladon Church is hoisted on to RML Dongedyk for
shipment to the US. American Express exploits the
moment with typically American good taste.

Shipped by **AMERICAN EXPRESS** International Freight

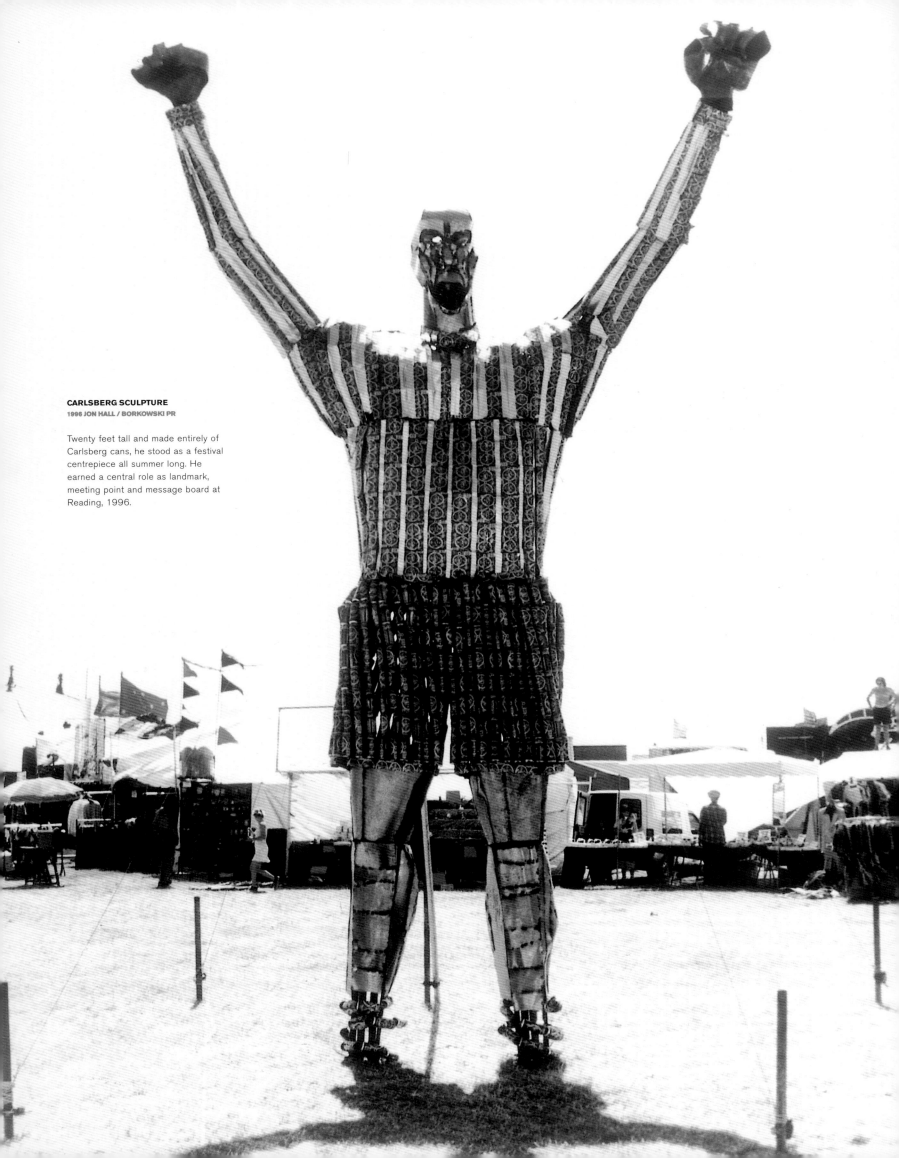

CARLSBERG SCULPTURE
1996 JON HALL / BORKOWSKI PR

Twenty feet tall and made entirely of
Carlsberg cans, he stood as a festival
centrepiece all summer long. He
earned a central role as landmark,
meeting point and message board at
Reading, 1996.

7 | **PRODUCT...**

GETTING THE PRESS TO WRITE ABOUT A
PRODUCT OF THEIR OWN FREE WILL IS NOT
LIKE CLIMBING A MOUNTAIN. THEY WON'T DO
IT JUST BECAUSE IT'S THERE.

They zealously guard their column inches against product placement. The publicist's job is to build a story around a product which the media can't afford to ignore. Sometimes stories are ripe for the picking, and all it takes is an inquiring mind and a journalistic sensibility to secure a three-page feature. But more often, turning humdrum products into front-page news demands bizarre inspiration and an instinct for the eye-catching.

One tale recounted by Candice Jacobson Fuhrman about Jim Moran encapsulates the whole wily transaction, from both sides of the publicist/press divide. Hired by Studebaker to promote Lark automobiles, Moran went on a twenty-city tour, using his own happiness-measuring invention, the 'hapometer', to locate "Miss Happy as a Lark". Wherever he went, he generated huge amounts of attention and attracted thousands of women eager to take part in the experiment for the chance of winning a car.

In the *Minneapolis Tribune*, a reporter tried to outwit Moran by filing a story packed with every possible name of car, bar the Lark. The story ran:

"Jim Moran is a world renowned rambler. In his many travels as a press agent, he has been known to ford a river or brave localities where the mercury knows no bounds in order to plant a sponsor's name. Moran is well known in Cadillac and Pontiac, Mich. and in the imperial palaces of the Orient. On the other hand he has never been in Buyck or Austin, Min.

"He has pulled many a dodge, but in general he is known in the trade as being solid as Plymouth Rock. Moran has a beard like Lincoln that gives many people the willies. He is built in somewhat Goliath proportions, and has the eye of an explorer like DeSoto. Moran was in Minneapolis promoting a contest to find "The Happiest Girl in America". The winner will receive a screen test and a new automobile, the maker of which is his sponsor"[9].

Gotcha. Sadly for the *Tribune* reporter, Moran bested him, because the story so tickled *Time* magazine that they reprinted it in full, as part of a feature on Moran and the Lark promotion.

The media is, at least in part, a branch of the entertainment industry, and can't afford to ignore the bizarre and off-beat. Whether manufactured for the public to promote product or not, these are real events, and the media is the richer for the input of this strange blend of creative inspiration and commercial necessity.

This is a strand of contemporary art, with business as its patron and newspapers as its hanging space, playing to an audience of millions. It will never win a grant or the Turner Prize, and it's all the better for it.

GOODYEAR BIG TYRE
1930 © DAS FOTOARCHIV

A hugely impressive piece of exotica from Goodyear
and as surreal as any Dali, it drove coast to coast in
the 30s and is seen here making a spectacle of itself
on 42nd Street in New York.

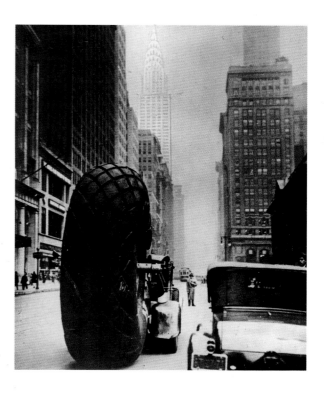

STREET OF SOFAS

1950 (C) UNIVERSITY OF LOUISVILLE

In this almost-convincing effort on the part of a
furniture store, you will note that from the sixth row
back, the sofas were drawn in. Still, the idea is
beguiling and the image is extraordinary.

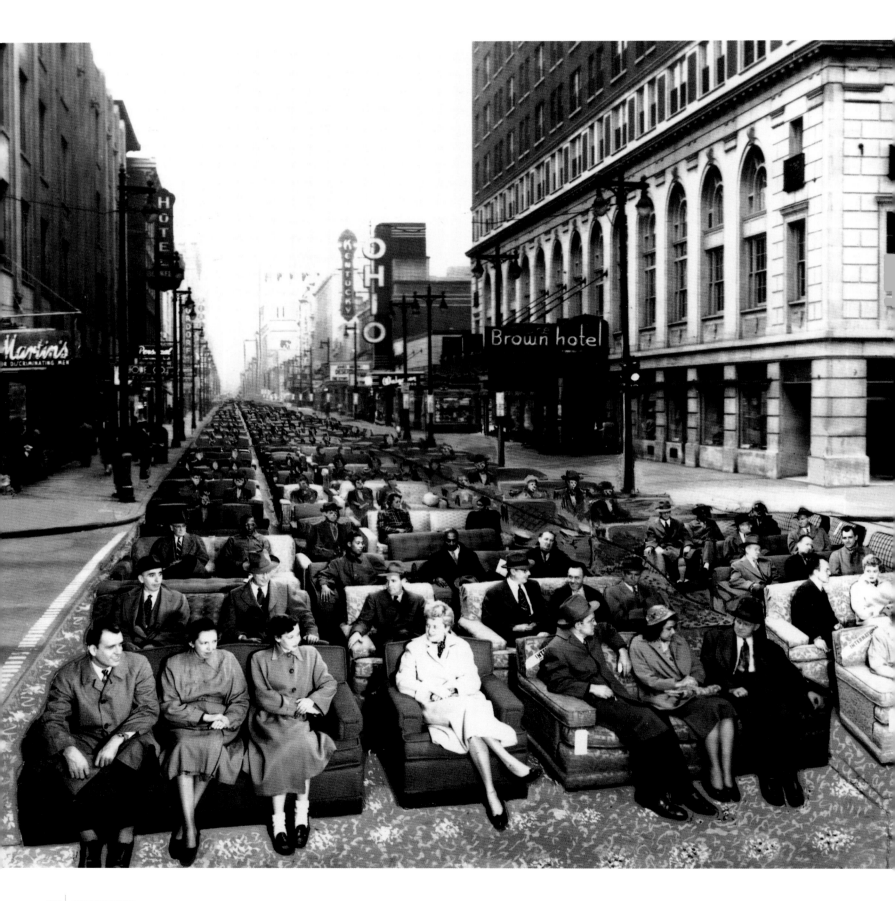

ICED SUNBEAM

1955 © BERT HARDY © HULTON GETTY PICTURE
COLLECTION

You can't even see the product, but once the picture has
engaged your interest, you soon learn the whole story.
Legend has it that a Sunbeam Rapier was undergoing
intensive cold-weather testing at the Rootes Factory in
Coventry. Over a period of days, the ice melted, resulting
in possibly the slowest but most intriguing unveiling in
the history of the automotive industry.

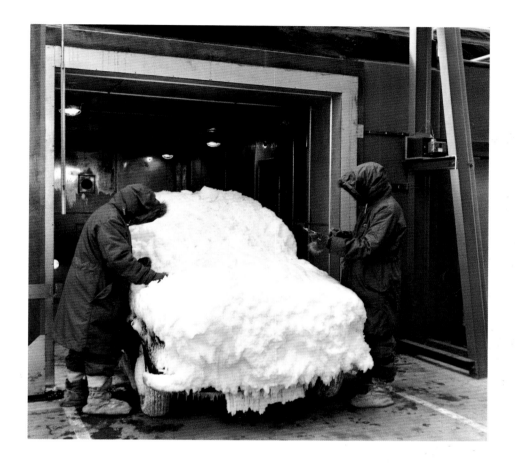

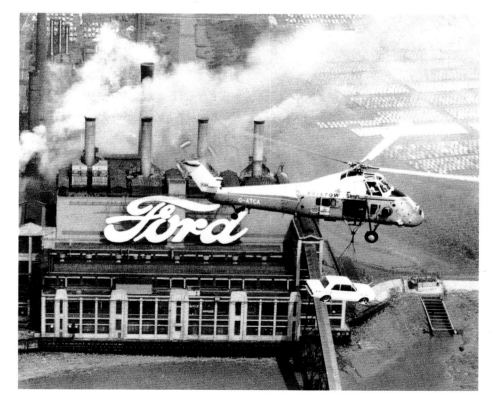

AIR-LIFTED CORTINA

1970 © HULTON GETTY PICTURE COLLECTION

Brilliantly eye-catching, this is nevertheless a blatantly
branded dramatisation of mildly interesting news.
Ford's one-millionth export Cortina hitches a lift to
Belgium, slung beneath a Westland Helicopter. The
owner, replete with keys and furry dice, took delivery
in his front garden.

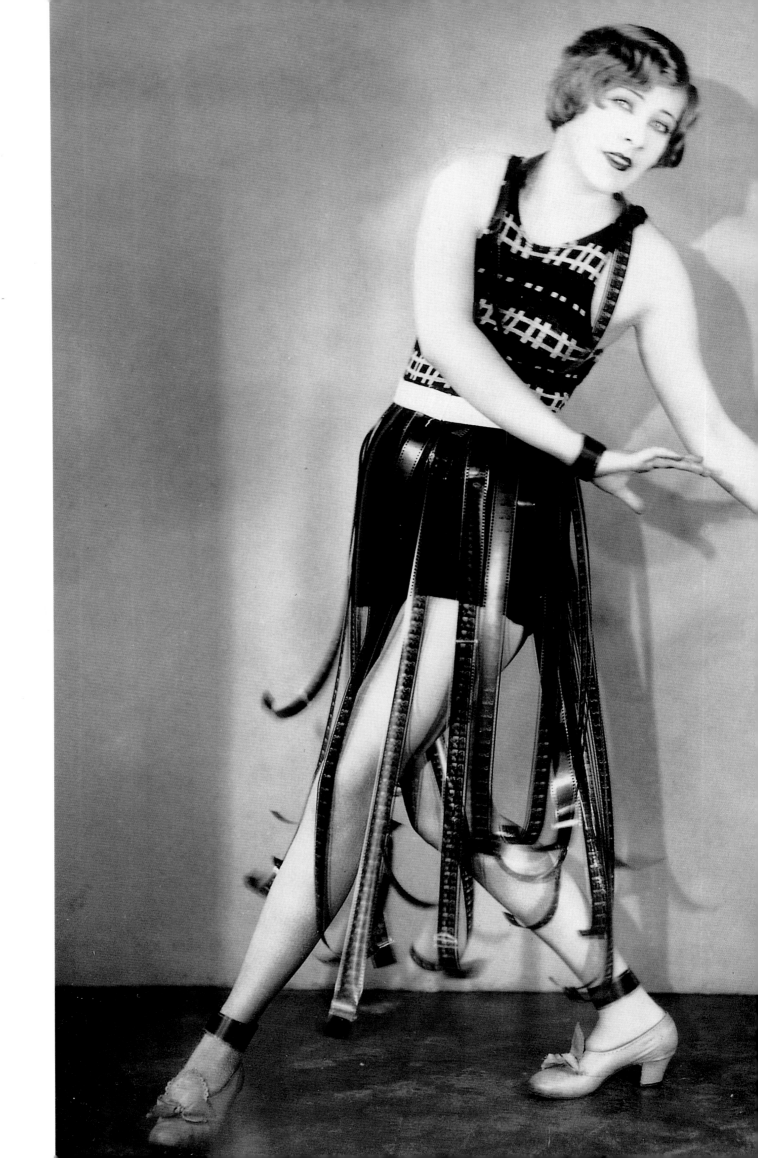

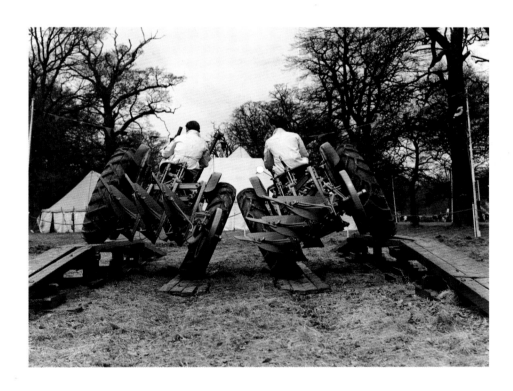

GWEN LEE

1926 © HULTON GETTY PICTURE COLLECTION

If she'd been a bit less modest and discarded the
knitted tank top, Gwen Lee could have slipped into
the sex section. The MGM actress models a celluloid
skirt made from her long-forgotten latest movie. (The
end credits are round the back.)

STUNT TRACTORS

1948 © HULTON GETTY PICTURE COLLECTION

Showing that the degree of sensation required to
secure coverage has developed somewhat, this
remarkably unremarkable promotion of Ford tractors
driving at a death-defying 25 degrees was a big hit
with the press in 1948.

BOTTLED BRITVIC GIRL

1994 BORKOWSKI PR

Rubber Woman Delia Dusol squeezes into a two-foot-tall bottle in a central London street. This exercise in re-packaging was designed to publicise the new design of Britvic's fresh orange container.

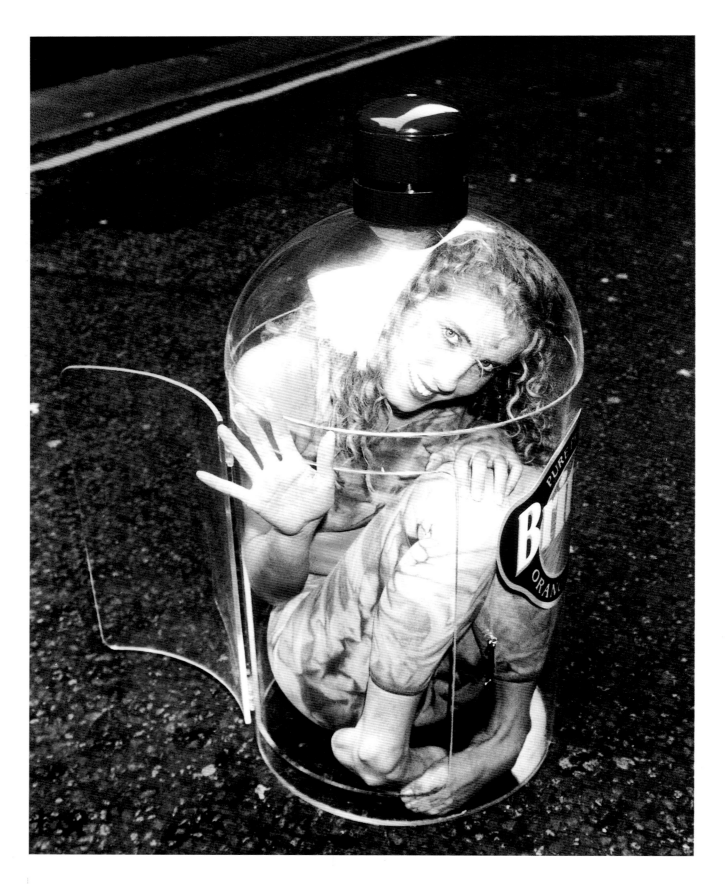

JIM MORAN SELLS ICE TO AN ESKIMO

1938 c UPI / CORBIS

Jim Moran - after successfully searching for a needle in a haystack to promote a real estate company, and literally changing horses in mid-stream to hype a political campaign - heads off to Alaska to exploit another aphorism. This time, ludicrously attired and overtly branded with the name of his sponsoring airline, he plans to sell a fridge to an Inuit.

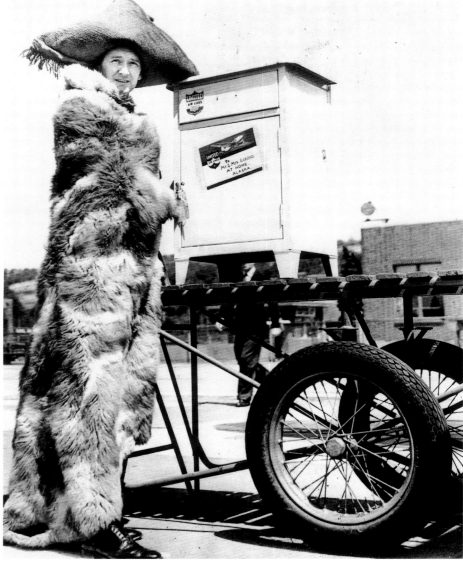

ACTION MAN: FREESTYLE STAR

1996 COURTESY OF HASBRO UK / BORKOWSKI PR

By turning Action Man into a real person with attitude, personality, and an evolving eco-agenda, he gained immediate media appeal. Here he is, taking up a Herculean front crawl challenge against Olympic medal winner Mark Foster. In the interests of scale and fair play, Foster swam three hundred meters to Action Man's fifty, and a crowd cheered their hero to an impressive victory despite a wayward period of mid-point nerves during which he swam round in a circle for 30 seconds.

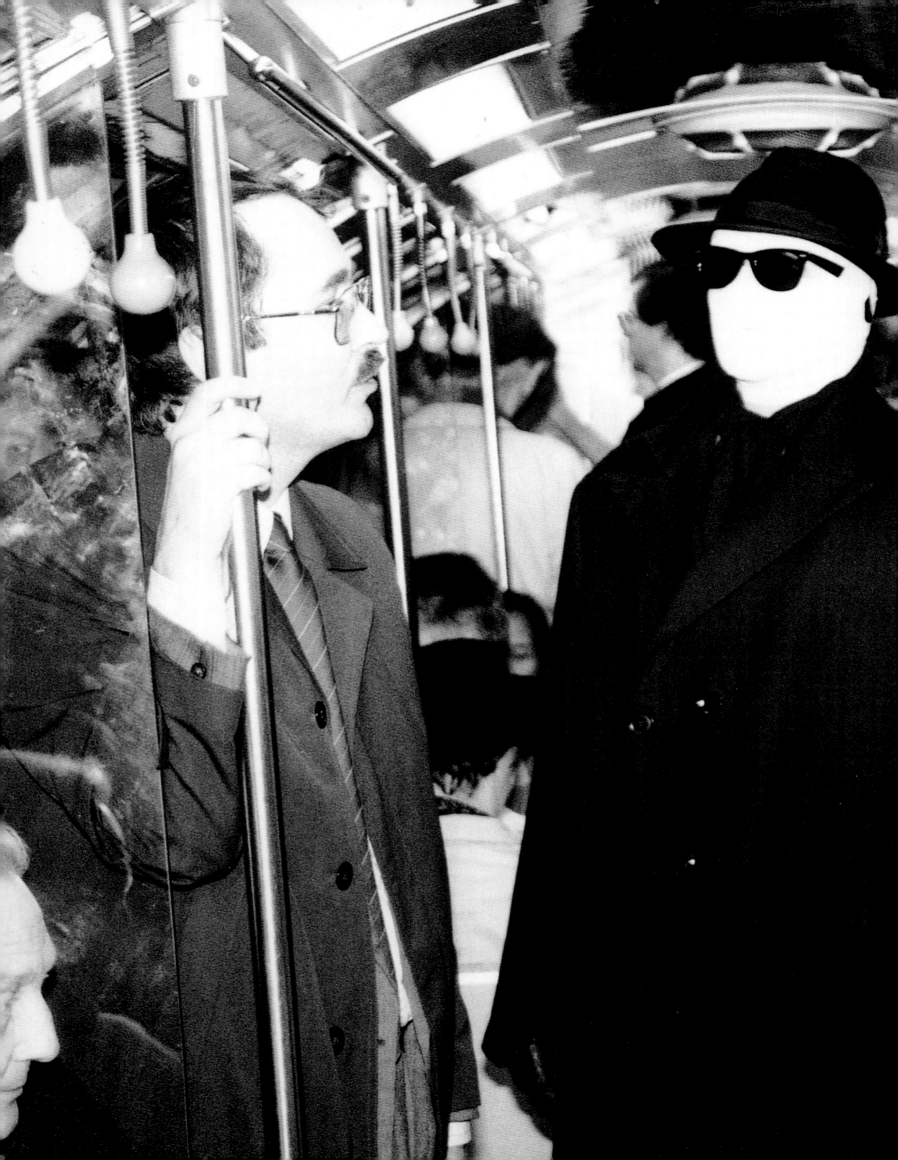

INVISIBLE MAN

1993 MARCEL MOBIL / BORKOWSKI PR

The Invisible Man is here visibly manifested as a mundane commuter, as part of his planned programme of West End rovings to promote the show of the same name.

PETROL-RATIONED FIRE EATER

1956 HARRY KERR © HULTON GETTY PICTURE COLLECTION

Demonstrated here is not so much a product as a lack of it, as fire-eater Priscilla Birt from Knightsbridge draws attention to the ongoing campaign for petrol rationing managed by the Ministry of Fuel and Power in the 50s. In the tradition of great British bureaucracy, she could only acquire the tool of her trade by applying for official classification as a stationary engine.

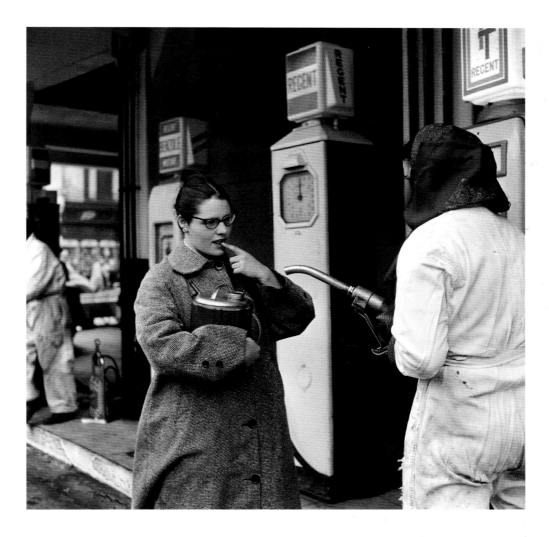

ORANJEBOOM - BEFORE
1993 BILL KENNEDY / BORKOWSKI PR

This poster was part of the Oranjeboom double Dutch
campaign - the nonsensical piles of Dutch turn into
clearest English when read aloud.

ORANJEBOOM - AFTER
1993 BILL KENNEDY / BORKOWSKI PR

After the most wanton act of desecration imaginable,
the brewer's message became hideously distorted.
Apparently there are some pretty smart vandals
knocking around.

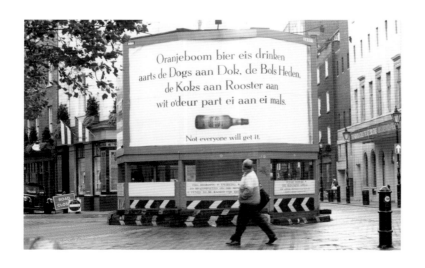

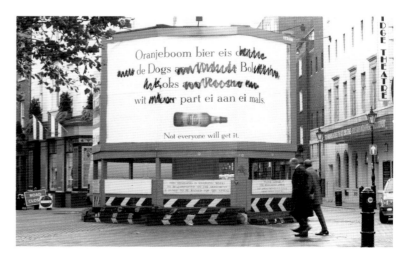

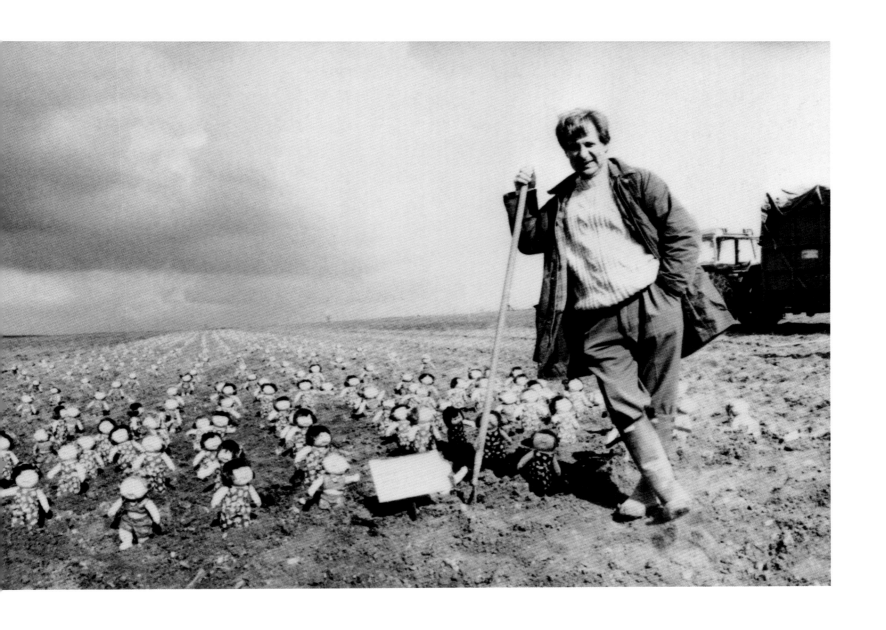

CABBAGE PATCH KIDS

1991 DAVID CORIO / BORKOWSKI PR

The pudgy one with a misshapen face is Mark
Borkowski, tending his harvest of Cabbage Patch
Kids at Sparsholt Agricultural College in Hampshire.
The date? 1 April, 1991.

TESCO SUPERMARKET SWEEP

1966 TERRY FINCHER © HULTON GETTY PICTURE COLLECTION

Not an illustration of Tesco's incompetence, this is rather a supermarket sweep staged in August 1966, featuring Joe Buzidragis, who received his fifteen minutes of fame in the UK on the back of his parents' prize-winning sweep in a US store. It's an authentic example of what the marketeers call FMCGs - fast-moving consumer goods.

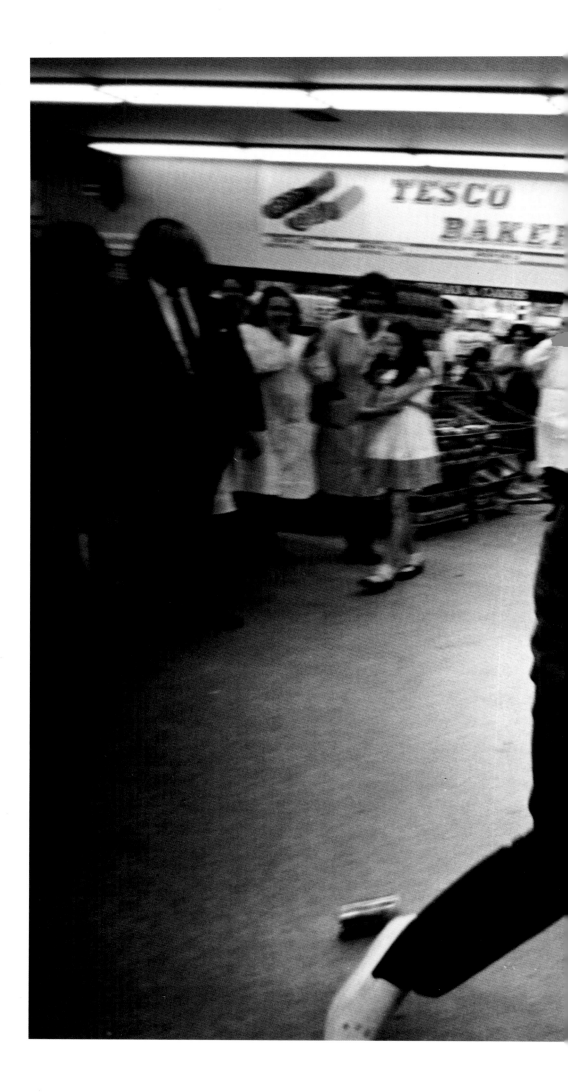

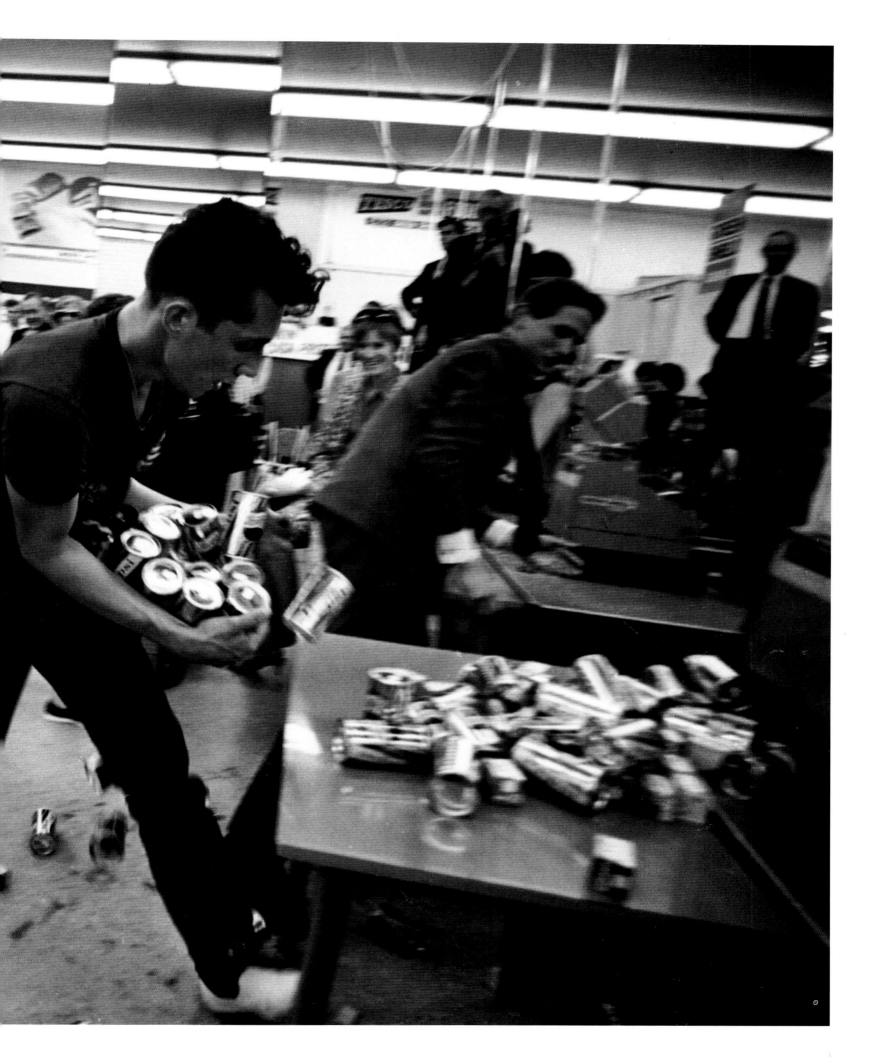

TANGO MAN

1991 COURTESY OF HHCL & PARTNERS / AD
DIRECTOR MATT FORREST

The media furore surrounding this unruly slapper
made Tango's name and turned cheek-smacking into
a brand statement.

GERMAN BULLETPROOF VEST

Here Dr Frankenstein's monster, circa 1925, appears
in a police recruitment campaign. Some would say
that the German riot police of the day hardly had
hearts or minds to protect, but they could rest
assured that any lingering pulse and residual brain
cells would be safe behind this alloy helmet and
bulletproof vest.

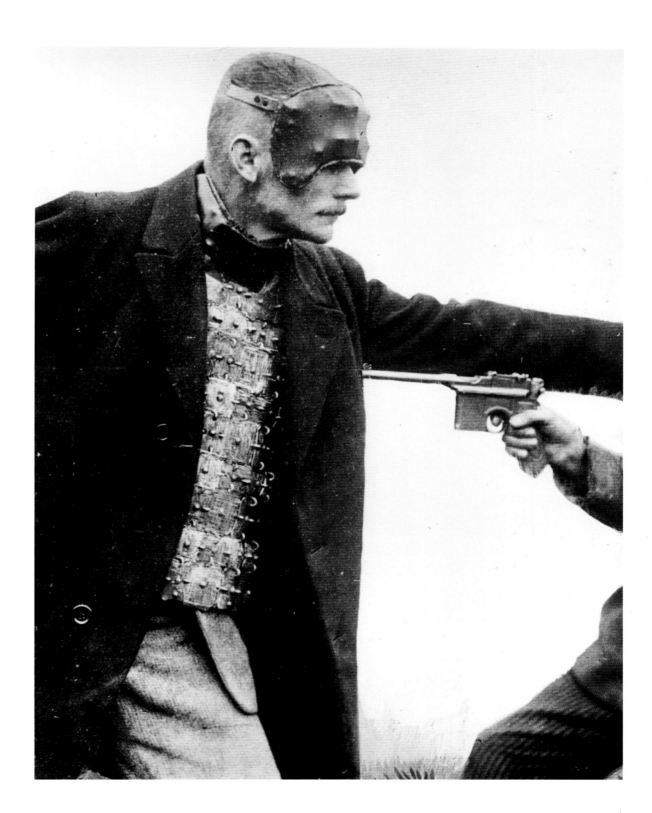

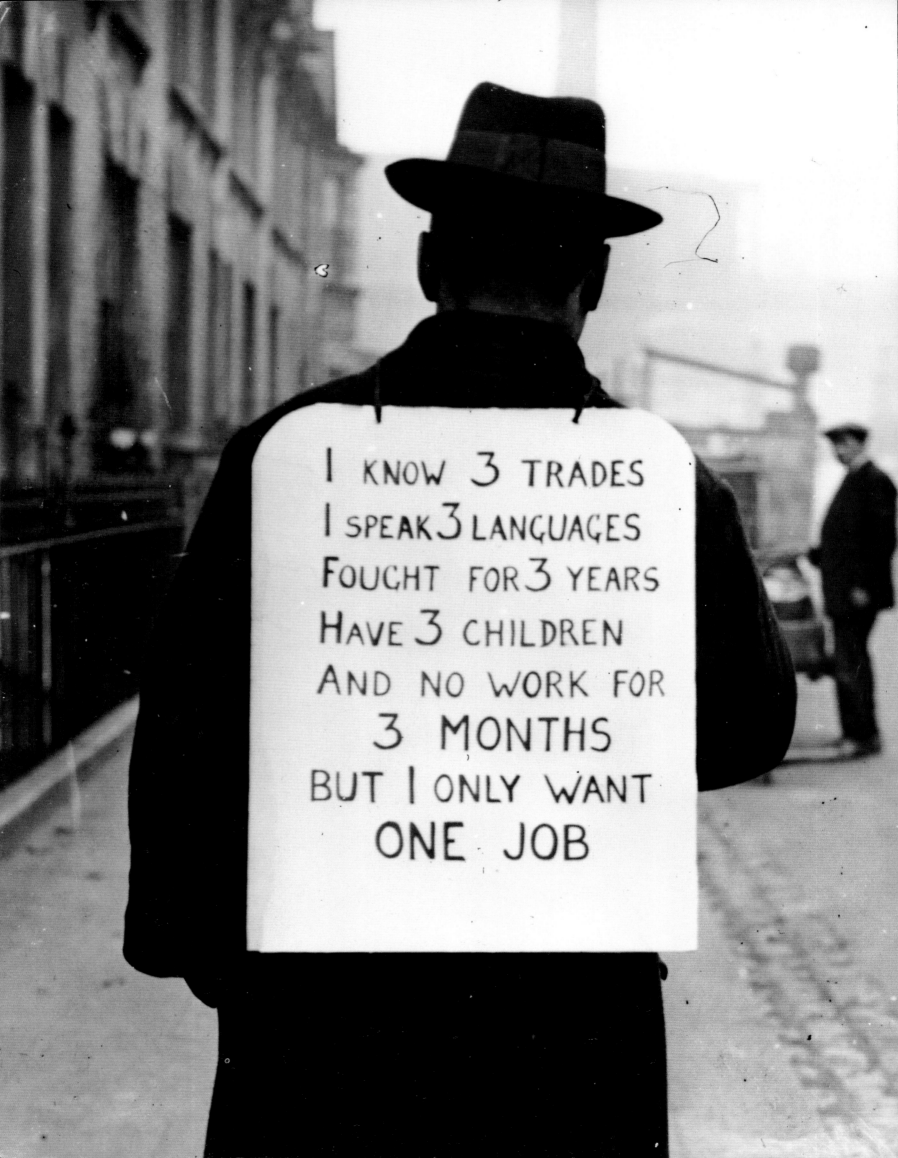

8 | PROTEST...

NEWS IS ABOUT SENSATION AND DISAGREEMENT. PROTEST IN THE MEDIA STARTS AT THE MOST BASIC: SOME WRITE Y-O-Y LETTERS TO RADIO 4 ABOUT TEN-MINUTE ALTERATIONS IN BROADCAST TIMES FOR THE SHIPPING FORECAST, AND OTHERS ARE DISGUSTED AND LIVE IN TUNBRIDGE WELLS. BUT MAKING NEWS, RATHER THAN COMMENTING ON IT, IS THE CREATIVE CAMPAIGNER'S ROUTE TO GAINING PUBLIC RECOGNITION. PROTESTS WHICH DISRUPT THE NATURAL FLOW OF EVENTS, AND WHICH INCORPORATE ELEMENTS OF THE BIZARRE AND PHOTOGENIC, ARE INSTANTLY NEWSWORTHY.

They don't have to be subtle. It's possible to generate millions of pounds' worth of media attention for little more than the cost of a barn-fresh Size 4 egg, and the two cans of Special Brew it takes for a release of Dutch courage. Protest has been a stock technique of PR over the years. The quintessential story is that of Harry Reichenbach[10]. Hired by a gallery to promote an exhibition, he set up a complex sting which involved placing a moderately risque print of a naked girl in the window, then contacted Anthony Comstock of the New York Anti-Vice Society to complain at the display of such a filthy picture. Once he had persuaded Comstock to visit the site, he hired a flock of children at fifty cents apiece to act out a pantomime of frenzied sexual excess. When Comstock arrived, the kids played out their part to perfection, and he demanded that the gallery owner remove the offending item. The owner refused; the disagreement entered the courts, and the matter became front-page news.

The stunt was repeated in other cities and the image was banned in New Orleans and Chicago. In 1914, the matter went to the First District Appellate Court of the United States, and in a rare moment of judicial insight into the PR world, the court ruled that the picture was not indecent, but commented that "the same may not be said of much of the exploiting to which it has been subjected". The print, September Morn, sold seven million copies.

Provoking protest is a frequently applied trick, but the question of the indecency of the technique raises issues of principle. When it comes to selecting images of protest, what starts as humorous ballyhoo slides through to the non-commercial promotion of beliefs, and ends up as sinister propaganda.

Classifying the offensive is subjective: fascists celebrate shots of the Nuremberg rallies, and WWI patriots approve of a picture of a conscientious objector humiliated in the stocks. The issue of debate, though, is the intent behind publishing the image: propaganda, says Paul Myron Anthony Linebarger in *Psychological Warfare*, consists of "the planned use of any form of public or mass-produced communication designed to affect the minds and emotions of a given group for a specific purpose, whether military, economic or political"[11].

Most publicists will draw a line at some point. The popular suspicion which attaches to the industry arises because those points are so various, and because a minority — as in any business — is prepared to pursue its trade without scruple.

A picture of two blue ferrets throwing custard pies at politicians is clearly promoting something other than dissident opinion. The media can take it or leave it, and the reader understands the game. Setting up a shot of Hitler embracing a baby, though, is an action undertaken with insidious intent, which reaches the public through a controlled media which serves the state's interest. One is information, and the other is disinformation: it's publicity versus propaganda.

The point at which information becomes disinformation is the point at which our awareness of the intent of the image becomes clouded. It's the moment that our ability to exercise free choice over interpretation is disabled, by context or by content. What follows is a journey down a curve of images, passing from absurd protests through vehement demonstration to pure propagandist deceit.

ONE MAN DEMO
1935 © HULTON GETTY PICTURE COLLECTION

This was a stark, simple, effective comment on unemployment in England in the 1930s.

FERRETS AND FLAT CHESTS

2000 PETER AITCHISON / BORKOWSKI PR

Bill the Ferret, icon of www.funplanet.co.uk, dons a
bra and latches onto Wonderbra model Kate
Groombridge during a National Cleavage Week
protest as part of a programme of planned
spontaneous anarchy at every paparazzi-packed
event in the media calendar.

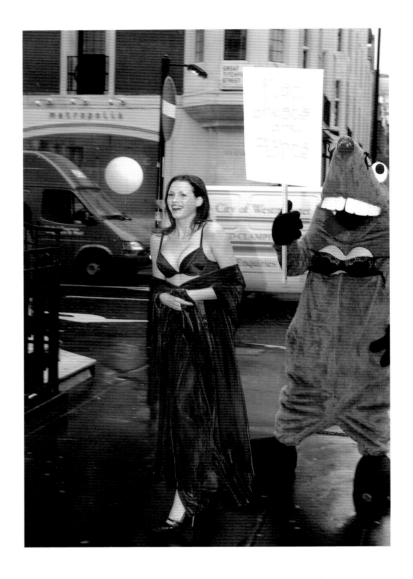

GLAD TO BE GREY

1985 MARK BORKOWSKI

In 1985, Peter Freedman's seminal handbook *Glad to
be Grey* called on the the terminally dull to celebrate
Grey Pride. Launched in a launderette, with a spread
of soggy jelly and cold tapioca and downed with tap
water, this stunt concluded with a march down South
Molton Street, with angry protesters making a stand
against the fashion elite's snobbish rejection (at the
time) of flares and cardigans.

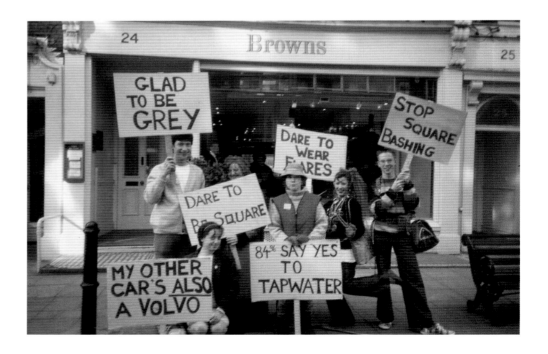

PETER MANDELSON'S PERSONAL DOME

Paramount Comedy Channel dumps on Millennium
Dome supremo Peter Mandelson, as the so-called
master of political media manipulation passes by
stony-faced, uncharacteristically lost for comment.

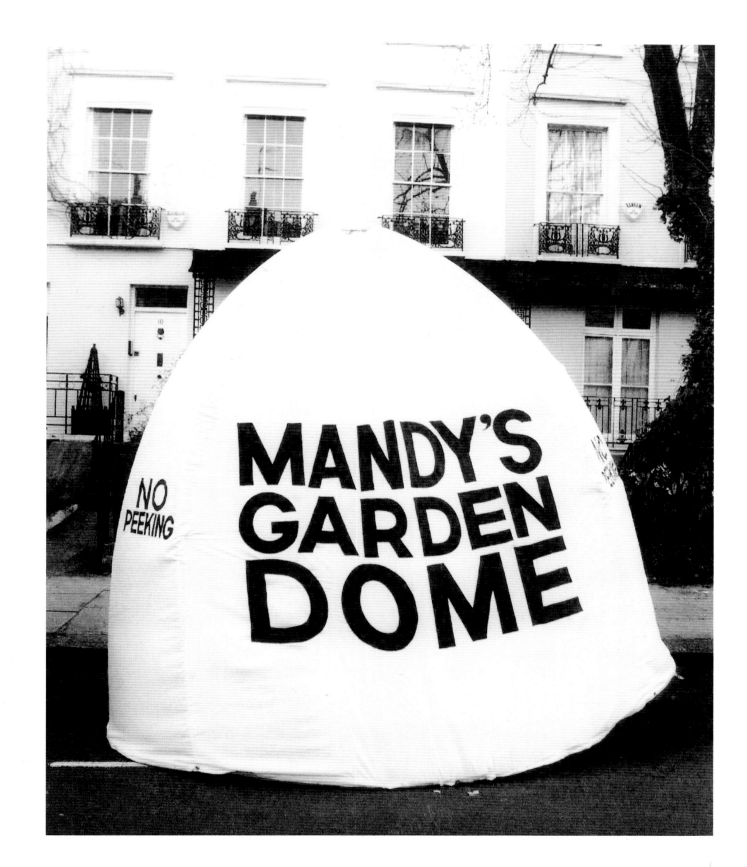

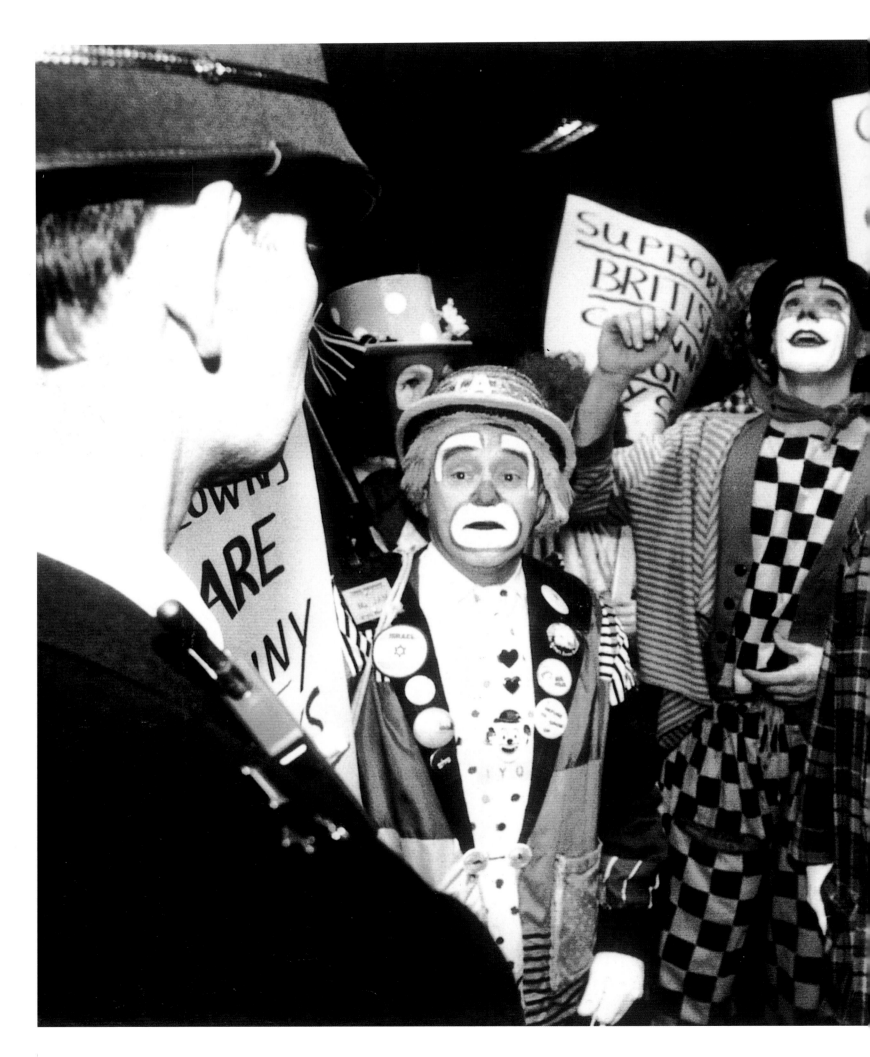

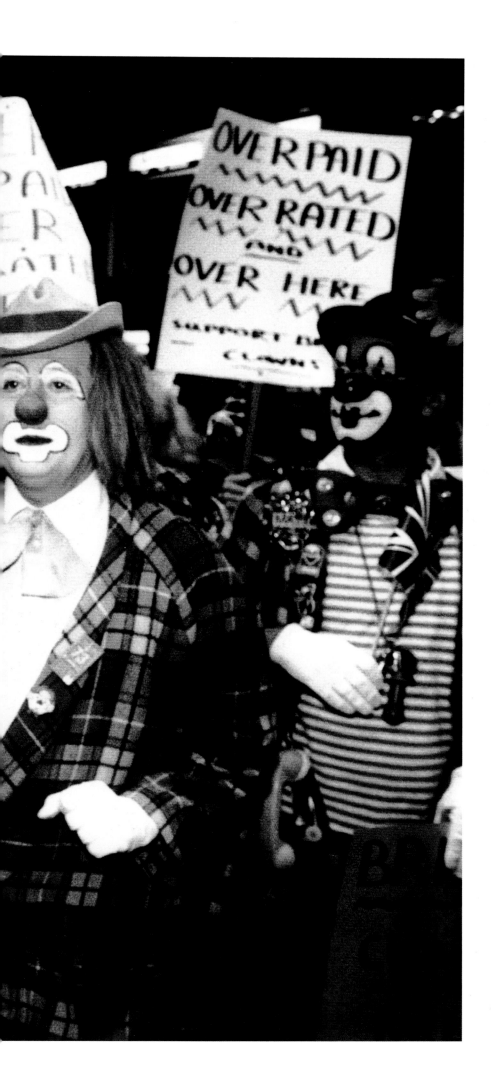

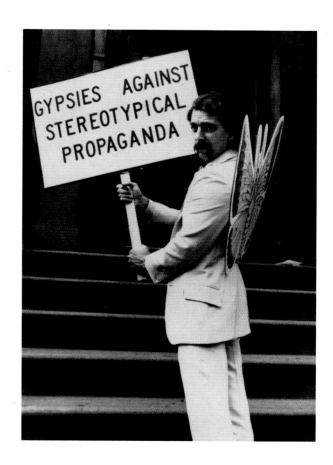

JOEY SKAGGS: KING OF THE GYPSIES

1982 © JOEY SKAGGS

Artist and prankster Joey Skaggs has manipulated
the media for decades, provoking and challenging its
agenda and the public's assumptions with enormous
wit and a flair for the absurd. This protest was for
GASP (Gypsies Against Stereotypical Propaganda):
as Jo Jo, King of the Gypsies, he called for a week-
long Tarot card down-tools as part of a campaign to
rename the Gypsy Moth (as a reviled agricultural
pest, he protested, its name cast negative aspersions
on the Gypsy community). His excellent website,
www.joeyskaggs.com, features work from the past
thirty years, such as the classic Cathouse for Dogs
and the giant brassiere which first made him famous.

CLOWN DEMONSTRATION

1992 MARTIN ARGLES © THE GUARDIAN /
BORKOWSKI PR

Gerry Cottle, after describing British clowns as
"unfunny and unoriginal", books American clown
Denise Payne for his Christmas circus. A humourless
picket arrives to protest.

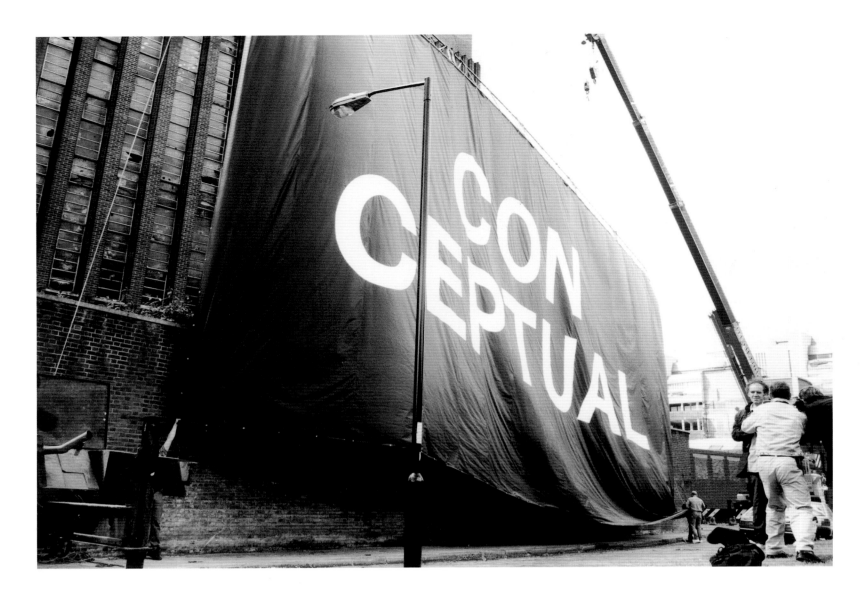

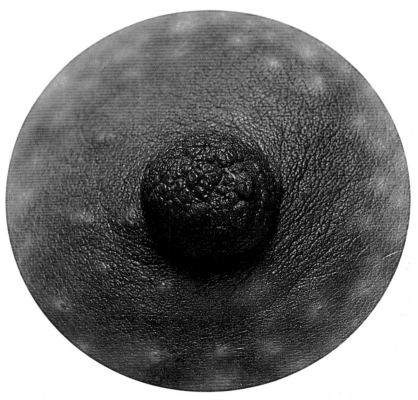

THE CON IN CONCEPTUAL
1995 JEFF GILBERT ⊂ **PA PHOTOS / BORKOWSKI PR**

Film director Tony Kaye mounts an elaborate protest
stunt outside the unrefurbished Tate Modern in 1995.
An expression of strong beliefs on contemporary art
fuses conveniently with strong beliefs regarding the
need to promote Tony Kaye as an artist.

NIPPLE NEWS
1993 WWW.GAVINEVANS.COM

An image of an erect penis can't be publicly displayed.
It's less well known that nipples – erect or not – are
subject to the same censorship. At least, half of them
are – while male nipples are pasted up all over the
place, female nipples must be airbrushed out or taped
up. This image was disseminated on posters
publicising DIS, an exhibition about the control of
information commissioned by Glasgow museums and
galleries. Photographer Gavin Evans was apparently
threatened with imprisonment for contravening the
Geneva Convention.

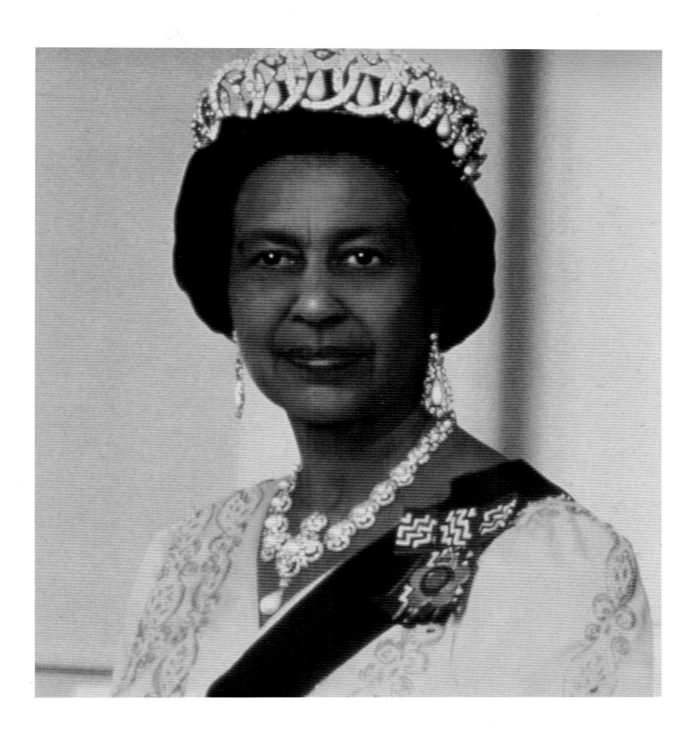

TREASON BY BENETTON

1993 © **COLORS 4 RACE /**
WWW.COLORSMAGAZINE.COM

Nothing to do with clothes and everything to do with
the promotion of a brand attitude, Benetton's
consciousness-raising campaign created an entirely
new angle on the commercial exploitation of
controversy. The Queen's ethnic makeover, by
COLORS 4 RACE, garnered huge coverage in a
nation sadly obsessed by those famously rich
anachronisms, Mr and Mrs Windsor.

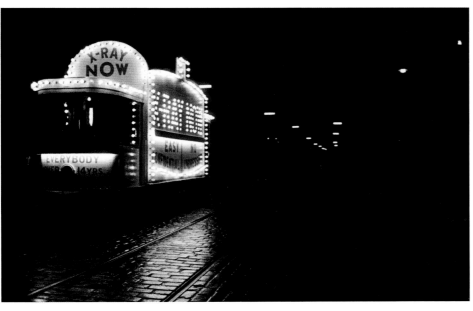

X-RAY TRAM

1957 **JOSEPH MCKEOWN** © **HULTON GETTY**
PICTURE COLLECTION

In 1957, this brightly-lit tram was employed as a
moving billboard to encourage people to attend X-ray
sessions at Glasgow's hospitals, to combat the
epidemic of tuberculosis sweeping the city.

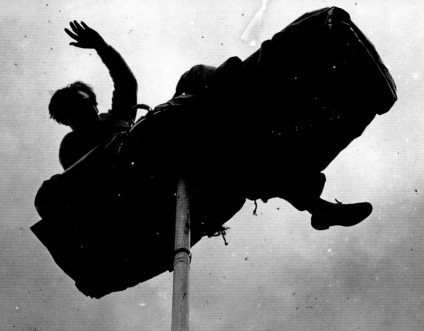

ANY EMPLOYEE
CAUGHT SENDING
UP FOOD TO
RENO
WILL BE
INSTANTLY
DISMISSED.
VIC.TEMPLAR

AA PETITION

1927 E BACON © HULTON GETTY PICTURE
COLLECTION

This campaign has yet to bear fruit: Automobile
Association scouts carry piles of petitions to their HQ
in 1927, seeking to prevent the government from
diverting road tax revenue to other purposes.

SEPTEMBER MORN

1913 FROM A PAINTING BY PAUL CHABAS

This picture achieved fame and seven million sales,
on the back of Harry Reichenbach's provocation of
moral minority outrage in 1913.

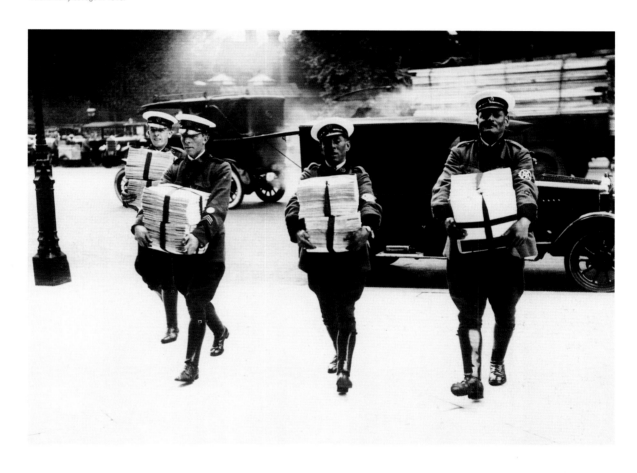

UP THE POLE

1950 © HULTON GETTY PICTURE COLLECTION

The acrobat Reno, aloft a forty-foot pole at Brighton
Zoo, protests Vic Templar's refusal to let him break
his contract.

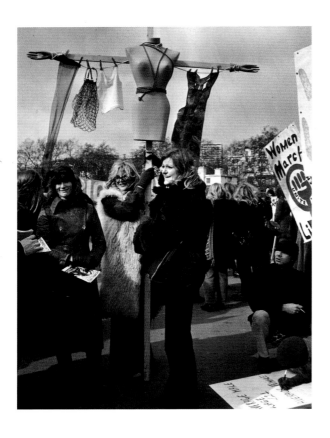

EQUAL OPPORTUNITIES

1978 © **HULTON GETTY PICTURE COLLECTION**

Edward Heath clearly missed the point. Maybe he
thought that by stepping aside to make way for his
famously masculine female successor, he was
answering the Women's Liberation Movement's calls
for Equal Opportunities.

JOHN AND YOKO -- BED-BOUND

1969 © **HULTON GETTY PICTURE COLLECTION**

Sincere political protest with a personal spin, this is
as much a defining image of the couple as a
statement of the cause. John and Yoko bed down
for seven days in the Hilton Hotel in Amsterdam as
part of their ongoing peace protests.

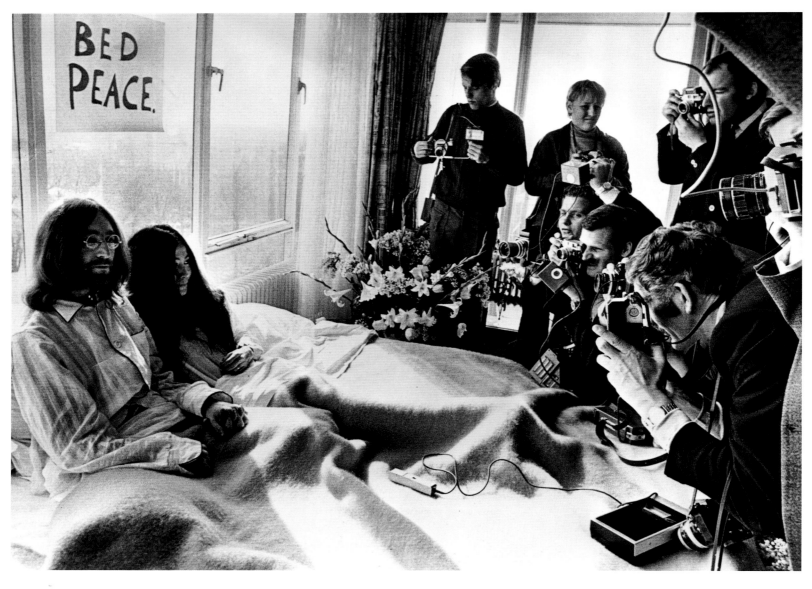

VANESSA REDGRAVE GRASSROOTS THEATRE

1990 JOHN VOOS © THE INDEPENDENT / BORKOWSKI PR

Protesting in a polite and traditionally British style, Vanessa Redgrave launches the Grassroots Theatre campaign to protest funding cuts.

GREENPEACE

1988 © GREENPEACE / GREMO

This phenomenal action also provided a brilliant image. As the U.S.S. Eisenhower steams into Palma in 1988, Greenpeace members risk their lives to draw the world's attention to the dangers of nuclear testing.

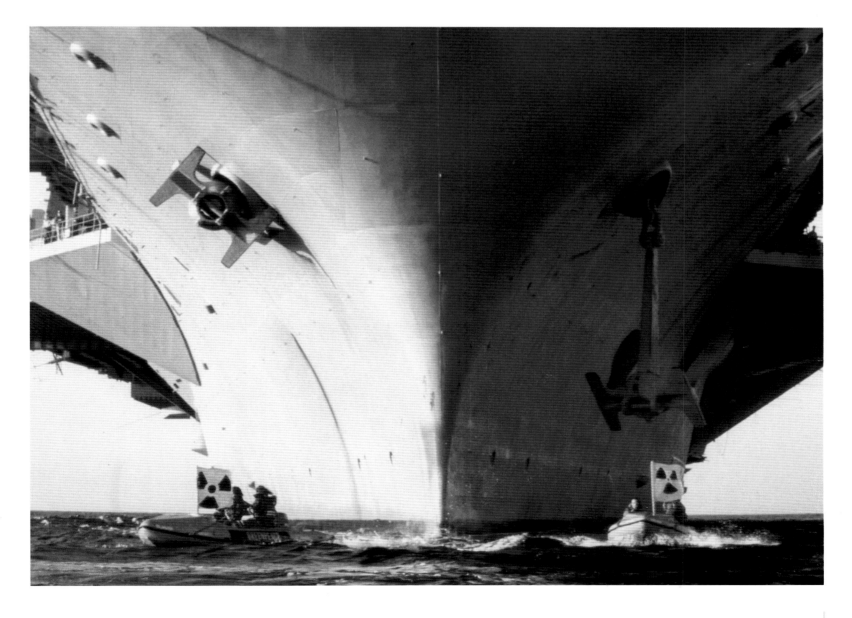

SELF-IMMOLATION
1963 © HULTON GETTY PICTURE COLLECTION

Saigon, 1963.

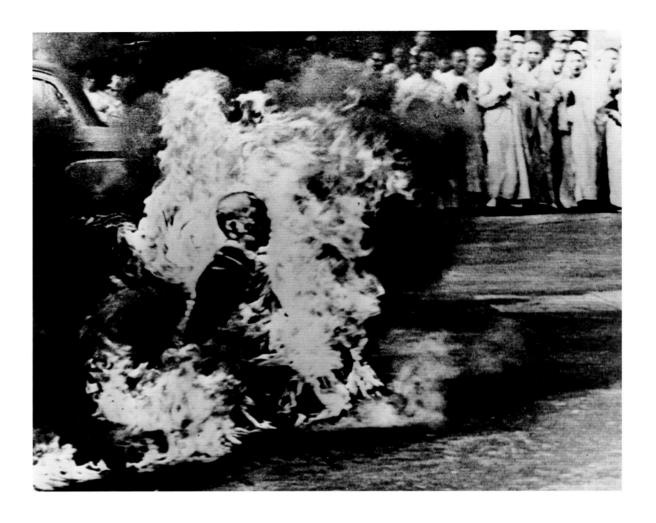

GANDHI
1933 © HULTON GETTY PICTURE COLLECTION

In March 1933, Gandhi fasts in protest
against British rule, after his release from
prison in Poona, India.

URCHINS IN UNIFORM
1914 © HULTON GETTY PICTURE COLLECTION

In 1914, as the need for cannon fodder
increases, London street urchins dressed as
soldiers demonstrate in Trafalgar Square,
standing to attention with canes as guns.

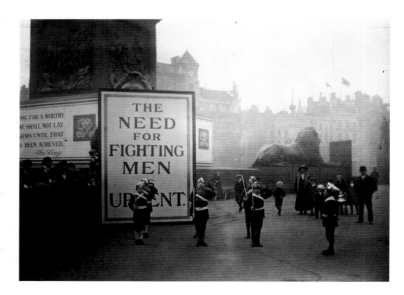

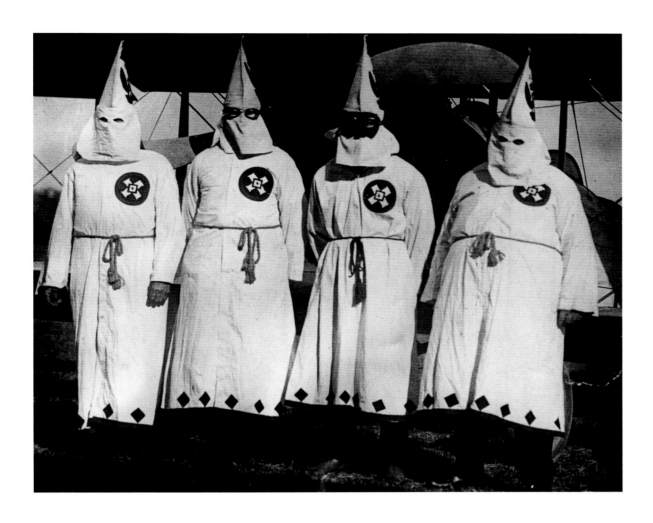

KU KLUX KLAN
1922 © HULTON GETTY PICTURE COLLECTION

Members of the Ku Klux Klan prepare to board an aircraft, out of which they dropped publicity leaflets over Washington DC in 1922.

TRAITOR IN STOCKS
1915 © HULTON GETTY PICTURE COLLECTION

A conscientious objector, 1915.

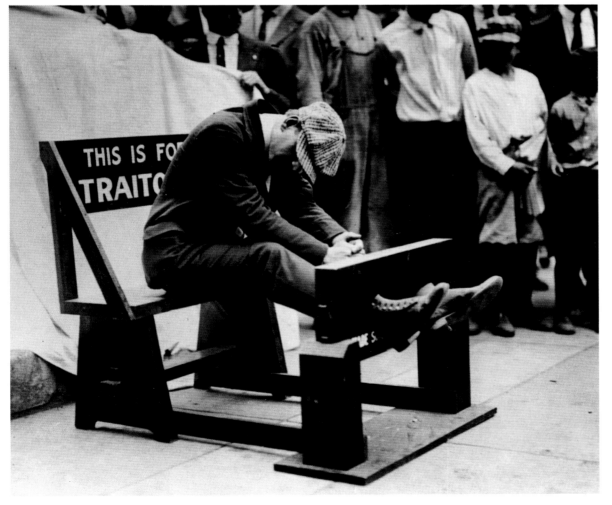

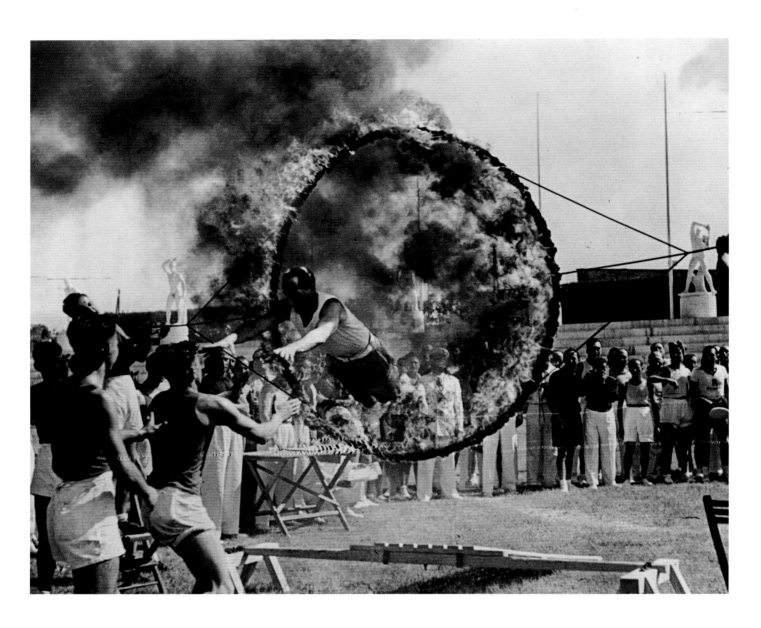

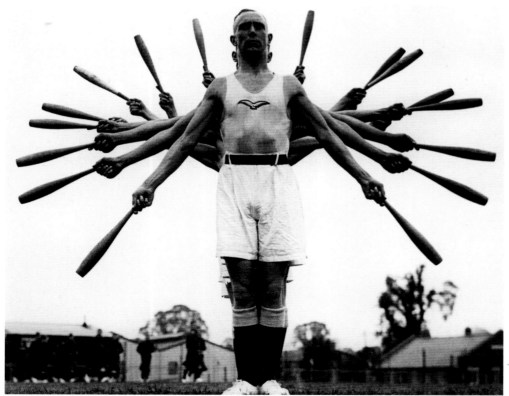

MUSSOLINI'S HOOPS
1938 © **HULTON GETTY PICTURE COLLECTION**

In 1938, Signor Achille Starace, Secretary General of the Italian Fascist Party, leaps through a blazing hoop at a physical fitness contest for officials in Rome, organised upon the orders of Benito Mussolini.

FIGHTING FIT
1934 ©**DAS FOTOARCHIV**

In 1935, the RAF gets into shape in preparation for history's first "war in the air".

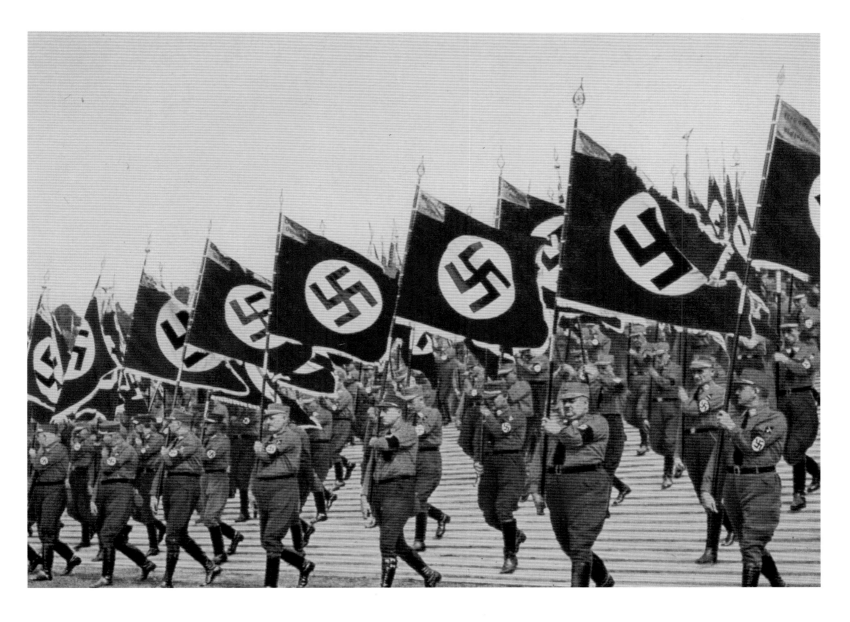

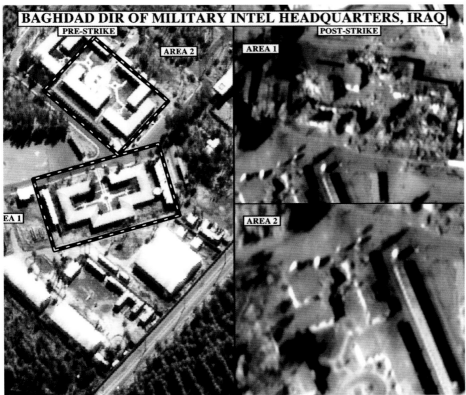

BAGHDAD DIR OF MILITARY INTEL HEADQUARTERS, IRAQ

PRE-STRIKE

AREA 2

AREA 1

EA 1

AREA 2

POST-STRIKE

AREA 1

NUREMBERG

1933 © HULTON GETTY PICTURE COLLECTION

Stage-managed by Goebbels, the original master of
political media manipulation, this entrance of the
colours is heroically styled at the German National
Socialist Party Day in Nuremberg, 1933.

BAGHDAD AIR STRIKE

1998 © US DEPARTMENT OF DEFENCE

War propaganda in a Playstation age: this is how the
US Department of Defence portrays the 'smart'
destruction of military intelligence headquarters in Iraq.

ABOUT THE AGENCY

B orkowski PR this year celebrates its 10th anniversary. This book has been produced by the agency as an illustration of the heritage and PR spirit which informs our work. We're rooted in entertainments PR, representing everyone from the orthodox to the bizarre. Over the years we've developed and exploited arts PR techniques in the service of an increasingly broad base of clients, which now includes blue chip companies, advertising agencies, the heritage industry and e-commerce operations. Whoever we work for, we always seek to employ creativity. Our staff come from disparate backgrounds, but the common thread is involvement in the creative arts at every level. Scanning current CVs, amongst others you'd find a fly poster, theatre administrator, actress, singer, event manager, writer, director, and wardrobe mistress - united in a common purpose, which is to make clients make news; united in a desire to practice the improperganda which this volume celebrates.

This is the first homage to improperganda in an ongoing series. Submit a selection of your favourite classic stunts for inclusion in Volume II to nourish@borkowski.co.uk. For more information, see www.borkowski.co.uk.

SOURCES

1 www.impropaganda.com
2 Fuhrman, Candice Jacobson. *Publicity Stunt! Great Staged Events that Made the News.* Chronicle Books, 1989
3 Fuhrman, Candice Jacobson. *Publicity Stunt! Great Staged Events that Made the News.* Chronicle Books, 1989
4 Fuhrman, Candice Jacobson. *Publicity Stunt! Great Staged Events that Made the News.* Chronicle Books, 1989
5 Fuhrman, Candice Jacobson. *Publicity Stunt! Great Staged Events that Made the News.* Chronicle Books, 1989
6 Dilinger, Jim. *Weekly Radical.* January 2000
7 Townley, Piers. *Loaded.* ipc Magazines, July 1999
8 www.impropaganda.com
9 Fuhrman, Candice Jacobson. *Publicity Stunt! Great Staged Events that Made the News.* Chronicle Books, 1989
10 Fuhrman, Candice Jacobson. *Publicity Stunt! Great Staged Events that Made the News.* Chronicle Books, 1989
11 www.impropaganda.com

Concept / Editor Mark Borkowski
Text Mike Gilmore
Project Coordinator / Image Research Ali Redford
Book Design Fruit Machine
Photographic Prints Joe's Basement
Reprographics AJD Colour Ltd
Print Godfrey Lang
Production Editor Emily Moore
Production Manager Steve Savigear
Publishing Manager Dan Ross
Publishing Editors Alex Proud and Rankin

Improperganda first published in Great Britain in 2000
by Vision On Publishing Ltd
T +44 207 336 0766
F +44 207 336 0966
112-116 Old Street
London EC1V 9BG
Email visionon@visiononpublishing.com

PHOTOGRAPHY BY
Gavin Evans, Stephen Sweet, Paul Massey, Mick Hutson,
Terry Logan, Pete Myatt, Francesco Escalar, Frank Haggis,
Peter McDiarmid, Geraint Lewis, John Voos, Peter
Aitchison, Jeff Gilbert, Martin Argles, Jim Hodson, Andre
Camara, Chris Harris, Trevor Beattie, Mark Borkwoski,
Robert Hind, Jon Hall, David Corio, Bill Kennedy, Marcel
Mobil, Nigel Sutton, Rui Xavier, Paul Bulley, Peter Scoones,
Leopoldo Samsa, Eamonn McCabe, Suzan, Dave Hogan,
Richard Young, Dave Bennett, Tom Pilston, David Sillitoe,
Ian Patrick, William England, John Chillingworth, Horace
Abrahams, Thurston Hopkins, Don, Graham Wood, Reg
Lancaster, H Thompson, Reg Speller, Heinrich Hoffmann,
A A Englander, Colin Davey, George Hales, William
Vanderson, Bert Hardy, Harry Kerr, Terry Fincher, Joseph
McKeown, E Baker, Gremo

THANKS TO:
Particular thanks to Gavin Evans, Bill Kennedy, Stephen Sweet, Peter Aitchison,
Trevor Beattie, David Corio, Jon Hall, Pete Myatt, Peter Scoones, Mick Hutson,
Paul Massey, Terry Logan, Sarah Mooney at Hasbro UK, Marcel Mobil, Leopoldo
Samsa, Francesco Escalar, Jim Hodson, Ian Patrick, Robert Hind, Gerry Cottle
and Joey Skaggs for the kind donation of their photographs
Jo Pearce, Vicki Watson, Sally Homer, Joanne McNally, Sarah O'Brien, Karon
Maskill, Lucie Speciale, Mandy Hershon, Andy Burgess, Brenda Hawes, Natasha
Redhead and Corrina Cottrell at Borkowski PR
Martin Bell and Wai Hung Young at Fruit Machine
Suzanne Bisset, Sarah Marusek, Stephanie Rivers and Diana Bell at Vision On
Alan Hamilton and Helen Hookway at Proud Galleries
Mark Andrews, Kerin Roberts and all at Joe's Basement
Andy Duffin and all at AJD
Colin Passmore at Godfrey Lang
Charles Merullo, Tom Worsley, David Allison, Katherine Bebbington, Matthew
Butson, Leon Meyer and Liz Ihre at the Hulton Getty Picture Collection
Rebecca Wood at Corbis
Kate Davison at Greenpeace
Eamonn McCabe and Judith Caul at The Guardian
Helen Paxton at The Independent Picture Syndication
Dave Bennett and Ray Blumire at Alpha Press
Simone at Rex Features
Chiara Zanoni at Colors
Laura Davis at Henry's House
Alex Brunner at Frank Spooner Pictures
Sara Murshed at Modus Publicity
Steve Nash and Nial Ferguson at FHM
James Anderson at University of Louisville
Chris Horak, Jeremy Laws and Cindy Chang at Universal Studios
Erika Kelly at U S Library of Congress Photoduplication Service
Jeff Jewel at Whatcom Museum of History & Art
Roberta Bridges at Paramount Comedy Channel
Erwin Schmidtbauer and Henning Christoph at Das Fotoarchiv
Tim Feleppa at Culver Pictures
Colin Grainger and Linda Kendall at Newham Recorder
Richard Bonfield at N I Syndication
Deborah Gatty at PA News Photo Library
Lorna McRae at All Action Pictures
Emma Challenger and Andrew Trehearne at the Leukaemia Research Fund
Franz Durant at Solo Syndication
Brian Whittle at Cavendish Press
Philip Stinson at Clintons
Geraint Lewis
Nigel Sutton
Johanna Martin
John Farquahar-Smith
Fiona Redford
And thanks to Dee McCourt, Deborah Goodman, Undine Marshall, Michael Park,
Melissa Cooper, Lisa Copson, Shelley Goffe-Caldeira, Miranda Kemp, Jane
Green, Chrissie Kyprianou, James Lovell, Holly Morris, Kate Harman and all who
have ever worked at Borkowski PR

PHOTOGRAPHIC COPYRIGHT © 2000:
Hulton Getty Picture Collection, FHM Magazine,
Leukaemia Research Fund, Das FotoArchiv, Bettmann/
CORBIS, Newham Recorder, US Library of Congress, The
Independent, Greenpeace/Gremo, COLORS 4 RACE, Solo
Syndication Ltd, PA Photos Ltd, The Guardian, Joey
Skaggs, www.gavinevans.com, Frank Spooner Pictures, N I
Syndication, Culver Pictures, Hasbro UK Ltd, University of
Louisville, Cavendish Press, Whatcom Museum of History
& Art, All Action Pictures, Rex Features, Universal Studios

The right of Gavin Evans, Stephen Sweet, Mick Hutson,
Terry Logan, Frank Haggis, Geraint Lewis, Peter Aitchison,
Jim Hodson, Trevor Beattie, Mark Borkowski, Robert Hind,
Jon Hall, David Corio, Bill Kennedy, Nigel Sutton, Eamonn
McCabe, Dave Bennett and Ian Patrick to be identified a
s the authors of their work has been asserted by them
in accordance with the Copyright, Designs and Patents
Act of 1988.

Printed in Spain by Book Print SL, Barcelona

ISBN 1903399009